Design FOR Response

ROCKPORT

Design
FOR
Response

CREATIVE DIRECT MARKETING THAT WORKS

GLOUCESTER MASSACHUSETTS

ROCKPORT PUBLISHERS

LESLIE H. SHERR & DAVID J. KATZ

First published in the United States of America by

Rockport Publishers, Inc.
33 Commercial Street
Gloucester, Massachusetts 01930-5089
Telephone: (978) 282-9590
Facsimile: (978) 283-2742

Distributed to the book trade and art trade in the United States by

North Light Books, an imprint of
F & W Publications
1507 Dana Avenue
Cincinnati, Ohio 45207
Telephone: (800) 289-0963

Other Distribution by
Rockport Publishers, Inc.
Gloucester, Massachusetts 01930-5089

ISBN 1-56496-380-2

10 9 8 7 6 5 4 3 2 1

Design: Otherwise Incorporated, Chicago
Cover images: Top left by BAMdesign; top right by Carbone Smolan Associates, photo by
Hugh Kretschmer; bottom by Hornall Anderson Design Works, Inc.; top of back cover by
Boxer Design; bottom by Michael Mabry Design, photography by Rick English.

Printed in China

Acknowledgments

It is to marketers and designers of great style and vision that we must turn to challenge ourselves, to evolve and grow. Too numerous to list here by name, you will find them in the pages that follow where, as writers, we have tried to venture into the thinking behind their creative brilliance. To them, we extend a heartfelt thank you.

Anyone who knows anything about making books knows the significant amounts of labor and teamwork involved in their creation. So, to Anistatia R Miller, who initially approached us with the idea, a thousand thanks. To our editors Shawna Mullen and Martha Wetherill for their gracious support, encouragement, and patience. To Jocelyne Henri, Valerie Viola, and Barbara Arn for their enthusiasm, time, and expertise. To Tom Patty, Martha Rogers, Ph.D., and Don Peppers, and John Kao, who taught us to see direct marketing through new eyes. Also, Michael Milley, Janice Pearson, and Julia Johnson.

I wish to thank three cherished souls who have always seen more in me than I have in myself, Eugene Kirkland, my co-author David, and my father Daniel Sherr.

Leslie H. Sherr

In addition to those Leslie has thanked above, I would like to give a special thanks to my children Matthew, Meredith, and Samantha, for their love. And to Leslie, without whom my world would be smaller.

David J. Katz

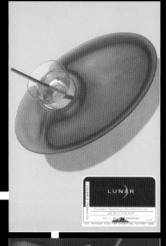

Contents

Introduction

WHY CLIENTS NEED PERSUASION PARTNERS (INSTEAD OF ADVERTISING AGENCIES)

by Tom Patty

For twenty five years, advertising agencies have operated as if they were in the "advertising" business. Most advertising agencies have been looking at this business from the wrong perspective; They have been looking at this business "from the inside out." But the reality is that you can't define a business from the inside out; you have to design a business from the outside in. As we've all been told many times by Ted Levitt and Peter Drucker, "your business is defined by the want the customer satisfies when he or she buys your product or service."

Why Do Clients Hire Us?

When you look at it from that perspective, it's pretty simple. What do our clients need? What want or need do we satisfy? Why do they hire us? Clients need two things. First they need people (consumers) to have positive opinions about their brand, their products, and their company. And second, they need people (eventually) to use their services or buy their products. Period. It's that simple.

Clients hire agencies because they believe that their strategic insights and creative messages help them persuade their customers and prospects to (1) have positive opinions about their brands, their products, and their company and (2) use their services or buy their products. They don't hire agencies because they need ads to hang on their office walls or because they need television commercials to entertain their friends or enter in awards shows. They hire ad agencies because they believe that they can help persuade consumers TO DO OR BELIEVE SOMETHING. Therefore it follows that we are really in the "Persuasion Business!"

Communication Versus Persuasion

Being in the persuasion business is very different from being in the communications business. Communication is not the same thing as persuasion, as a few examples will demonstrate.

A sign on the side of the road that says "speed limit 55 miles per hour" is communication. But a highway patrol car on the side of the road is much more persuasive.

A sign that says EXIT is communication; a person yelling FIRE is persuasion.

A great communicator can elicit a favorable response. When he finishes speaking, people will say "What a great speech." But a great persuader will leave the audience with a different reaction. Instead of focusing on the speech, they will be motivated "to do" something. For example, instead of saying "great speech," they might say "let's march," or "let's go to war." This was the difference between Cicero and Demosthenes; Cicero was a great communicator, Demosthenes was a great persuader.

Communication deals with the "what." Persuasion takes communication one step farther by focusing on the "why." It focuses on the benefit and the relevance to the personal needs of the audience.

Not surprisingly, many people in business confuse communication with persuasion. In fact, it is easy for a person in power to confuse the *power of persuasion* with the *persuasion of power*. For some executives, the concept of persuasion is very simple. They send out a memo telling people what they want to happen and then they assume that the recipients will be persuaded to do what was requested.

While this approach usually works with employees, unfortunately, it does not work so well with consumers. The corporate executive who says "just tell consumers how good our products are" doesn't understand the fundaments of persuasion. It isn't simply a matter of communication; it is a matter of persuasion.

The Persuasion Partner
Clients don't need agencies, they need persuasion partners. Clients need people who are experts in persuasion, people who understand the *elements of persuasion*, people who understand the *mechanics of persuasion* (the science and art of persuasion) and people who understand how to utilize the *tools of communication* to accomplish a complete persuasion plan.

The persuasion partner is like a skilled mechanic with a tool box. In the tool box are an assortment of communication tools—general advertising, retail advertising, direct marketing, promotions, public relations. But before the mechanic can select the proper tool, he/she must understand how the engine works and what the problem is.

The role of the persuasion partner is to determine—in each particular case and for each individual circumstance— the MEANS of persuasion. In other words, the persuasion partner must figure out what will work in each different situation and for each different audience.

In order to figure out *the means of persuasion* in each particular case, one must:
1. Understand the elements of persuasion (including the physiology of persuasion)
2. Determine the purchase process for the given product or service
3. Determine the persuasion task for each stage in the purchase process
4. Determine the credibility of the brand or speaker
5. Determine the personality of the brand or speaker
6. Develop a fully integrated persuasion plan

Let's start by examining the elements of persuasion.

The Elements of Persuasion
The essential elements of persuasion are not new. In fact,

Aristotle defined them 2,500 years ago in a work entitled *Rhetoric*. Since no one has improved upon this, let's take a look at how Aristotle defined the three essential components of persuasion. We'll take a look at each of these elements in turn.

The Content of the Message: The first part of any attempt at persuasion is to figure out "what" to say and assemble the necessary facts and evidence to support this claim. This includes the positioning, the strategic approach, and the evidence.

In the advertising/marketing world, this activity and focus has tended to dominate the activity of marketers for the past twenty years. Books have been written and lectures delivered on the importance of positioning, finding the USP, and other attempts to improve the "content" of the message. In addition, we frequently have focus groups and brand managers all focused upon trying to find the holy grail in determining "what" to say.

As important as this element is—and it *is* critically important— we must remember that this is only one third of the persuasion equation. There are two other elements—the credibility of the speaker and the involvement of the audience—that are just as important.

The Credibility of the Speaker: Here is a simple fact: When it comes to communicating with another human being, *"what"* we hear is not necessarily what they say. Much of what we "hear" is based upon our assessment about the "credibility" of this speaker. The same exact message delivered by two different speakers will have different levels of persuasiveness, depending upon the credibility of the speaker. Everyone knows this intuitively. And people pay lip service to this; but few communication managers really take this to heart in terms of thinking about the credibility of their brand.

What is the credibility of your message? Are consumers predisposed to believe that what you tell them is true? Or are they skeptical? It is interesting that with all the attention paid to finding the proper positioning and the right strategy for the message, by comparison, relatively little time and energy is spent in trying to gauge the *credibility* of the message among consumers.

The Emotional Involvement of the Audience: The third element in the art of persuasion is to get the audience emotionally involved with what you are trying to say. Bill Bernbach was a master persuader who understood this. He said, "In order to persuade someone, you must touch them personally. You don't persuade people through the intellect."

Another aspect in getting people involved is knowing the motivations and desires of the consumer. Does your product represent a "want," a "need," or a "have-to-have?" This relates directly to the purchase process—where is the consumer in the persuasion or purchase process? We'll discuss this in greater detail later.

As persuasion partners, it is critical that we create communication that acknowledges each of these three elements of persuasion.

In evaluating the *content* of the message, we should make sure that we have assembled the best facts, the most compelling evidence. In addition we need to package and position this information in a way that makes it fresh, new, and interesting to the audience.

In evaluating the *credibility* of the speaker, we need to determine if this speaker (the Brand) is someone who is believed and liked by the audience.

And finally, in evaluating the potential involvement of the audience, we must insure that the message is relevant to their needs and wants and is consistent with a deep understanding of their motivations.

The Physiology of Persuasion

So far we have touched on the Elements or Tools of Persuasion. But we must move beyond this elementary understanding and take a look at the Physiology of Persuasion. How does persuasion work in the mind of the consumer?

We human beings (Homo Sapien Sapiens) have been around in pretty much our current form for about 30,000 years. But a lot of the more interesting things about the evolution of the human brain happened way before this, like about 500 million years ago.

The human brain developed like a house where the owner just kept adding on rooms. Without getting rid of the old ones. Your modern brain has all the old brains inside it. You have the brain of a reptile and the brain of an ancient mammal right there underneath your modern cerebral cortex.

The human brain developed in three major phases—first, there was the Reptilian brain, which developed about 500 million years ago. The Reptilian brain determines our basic level of alertness and is in charge of basic bodily functions like breathing and heart rate. In technical terms, this is referred to as the *brainstem*.

The next phase of brain evolution was the *mammalian brain*, which was developed about 200 to 300 million years ago. In technical terms, this part of the brain is referred to as the Limbic System. The Limbic System helps maintain body temperature, blood pressure, heartbeat rate, and blood sugar levels. But the big thing about the Mammalian brain (Limbic System) is that *this is the seat of our primary emotions,* such as survival, sexual desire, and self protection. The key point here is that our emotions were here long before our logical, rational brains were developed.

The most recent addition (about 200 million years ago) to the brain is the *cerebrum*. As everyone knows, it is divided into two hemispheres (left brain and right brain) each of which controls its opposite half of the body. Covering each hemisphere is a layer of nerve cells called the cortex. It is this part of the brain—the cerebral cortex—that

"makes us human." Because of it, we are able to organize, remember, communicate, understand, appreciate, and create. The cortex has been called the "executive branch" of the brain because it is responsible for making decisions and judgments on all the information coming into it from the body and the outside world.

Previous discussions about persuasion have focused upon the functions of the NEW Brain—the important aspects of language, memory, cognition, creation. *This has led many people to conclude that humans are very logical and thoughtful creatures. It has led us to believe that we are rational beings.* If you want to persuade a rational being of something, just provide new rational information and the rational being will immediately adopt it. This is a little like the mentality of the CEO whose notion of persuasion is simply to send out a memo telling people what he wants them to do. Or the executive who says, "We have good products. Just tell consumers that our products are good and they will buy them."

Unfortunately, as we said, the new brain did not replace the old (reptilian and mammalian) brains. It was just added on top as a new addition to this rambling house. The old parts of the house are still there.

Credibility of the Speaker

As we learned from Aristotle, one of the three essential elements of persuasion is the level of credibility of the speaker. It should be obvious by now that effective persuasion involves a lot more than simply transferring information from one person to another. There's more to persuasion than simply "Telling people how good our products are."

In fact, Bert Decker, in his book entitled *You've Got To Be Believed To Be Heard,* talks about the physiology of the brain and its relationship to credibility and likeability. According to Decker, "There is a gate between us through which communication must pass. The gate is tended by a Gatekeeper, standing guard before the House of the Intellect. The Gatekeeper's name is the FIRST BRAIN." (Decker, page 47) (In our terminology, this would be the Limbic System or the Mammalian brain. The seat of emotions.)

"To reach the New Brain (the Cerebrum), our message must first pass through the First Brain, the emotional part of the brain. The reason the First Brain is so important is because it is the seat of emotion and emotional response. It is clear that the most important language in efficient communication is always an unspoken language, THE LANGUAGE OF TRUST. In order to be persuasive, you must make emotional contact with the listener. People buy on emotion and justify with fact and we must be believed in order to have impact— and that believability is overwhelmingly determined at a preconscious level." (Decker page 50-51)

"Whenever we communicate, our listener's Gatekeeper is right there on guard, figuratively asking, 'Friend or Foe?'

The Gatekeeper has complete power to grant or deny access to our listener's higher analytical and decision-making processes. A new communicator is a person who knows how to befriend the Gatekeeper, who knows how to become 'First Brain Friendly,' so that his or her message can get through effectively and persuasively." (Decker, page 47)

"If you want to get your message across, you must reach and connect with the First Brain. You must persuade your listener's First Brain that you are trustworthy—that you are likeable—that you represent warmth, comfort, and safety." (Decker, page 51)

Decker's argument is supported by practicing neurologists like Richard Restah, M.D., who writes, in a book entitled *The Brain Has a Mind of Its Own,*

". . . The limbic system is capable of overwhelming the cerebral cortex, wherein many of the reasonable person's most reasonable attributes—like interpretation, judgment, and restraint—are formulated." (page 52)

This understanding of the first brain and the new brain leads us to some interesting conclusions. Namely, before one can be persuasive, one must be credible.

This is why it is so important to determine the current credibility of the brand. *The more credible and likeable the brand is, the LESS information we will need to provide in order to persuade consumers to think or do something.* And conversely, the less credible and less likeable a brand is, the MORE information, the more evidence, we will need to provide to consumers for them to be persuaded.

Think of a couple of concrete examples: Honda and Nike. Both of these brands have very high levels of credibility and likeability. The Honda television commercials don't offer much information. They just show the car and reinforce the basic message that Honda vehicles are dependable and won't let you down. Similarly with Nike; many years ago Nike established its authenticity. Nike is the authentic brand for real jocks. And in their commercials they don't give you reasons to buy, they just reinforce their core message— Nike is the authentic brand of real athletes and it's "cool" to be seen wearing this brand.

But what would you have to do to effectively persuade someone to buy an Audi after all the negative publicity? What would you have to do to persuade someone to consider a Hyundai? Clearly the persuasion task is much more difficult and complex for a brand with a low credibility and likeability.

The Involvement of the Audience
The third element of effective persuasion is to create an emotional response in the audience. Before we start talking about how to influence the emotions, we need to know about how emotions work from a physiological point of view.

As Restah concludes in his book *The Brain Has a Mind of Its Own*, "…emotions are not incidental and subsidiary to rational processes. Even at his or her most reasonable moments, and despite all best efforts to the contrary, a person remains strongly influenced by feelings and emotions." (page 54)

Interestingly, emotions don't seem to have the same routing inside the nervous system as does more ordinary information. According to Robert Ornstein (in a book entitled *The Evolution of Consciousness*, page 80), "Emotional information fed into the brain enters via a different neural network than other, perhaps, more ordinary information. Most of our brain science has until recently assumed that all signals to the cortex travel over the same routes, but this seems not to be so."

We all know about the Right Brain and the Left Brain. But did you know that the different hemispheres process different components of emotion? Did you know that the left brain is tuned to respond to the verbal content of emotion while the right brain responds more to the non-verbal components of communication, such as tone and gesture? Furthermore, it seems that the evaluation of good or bad is built in below the level of consciousness.

"It seems that the positive/negative emotional system is the most primary. Most of our questions about events center on whether they are good or bad. And such evaluations seem built in below consciousness as well. People who see strangers subliminally start to like those they've seen more often than those seen less. Emotions appeared first in the mind's evolution, to operate as special-purpose organizers. Second, they are at the front line of our experiences. Since they evolved to short-circuit deliberations, they spring quickly into action, before rational deliberation has the time to function. So the common experience of not knowing why we are attracted to someone may have a basis that is unavailable to our normal understanding." (Ornstein, page 92)

Again, this is confirmed by Restah:
"An inexplicable but plainly measurable burst amount of activity occurs in your brain prior to your conscious desire to act… the brain 'decides' to initiate or at least to prepare to initiate the act before there is any reportable subjective awareness that such a decision has taken place . . . the brain is actually in operation before our conscious act of will." (page 46)

In everyday language, we have a word for this. It's called "intuition." Intuition is the feeling that we know something at a deeper level than consciousness. It is a "gut" feeling. It is part of our Mammalian brain.

We frequently act on impulse, before thought has occurred. Examples include acts of heroism, acts of survival, actions where the adrenaline pulses through the body and we spring into action without any cognitive activity.

As human beings, sometimes we act on emotion and use the new brain—the cerebral cortex—to help us justify our actions and our feelings. It has been said that man is less a "rational" being than a "rationalizing" being. But what does this have to do with persuasion?

Clearly, we are *emotional* as well as rational beings. In fact, someone has convincingly argued that we are more properly defined as "rationalizing beings" rather than rational beings.

At a very basic level, we are driven by two primary emotions: Hope and Fear. In designing persuasive communication, we need to link the right emotional cues to the message. Negative emotions (fear) are frequently utilized in trying to persuade someone to stop doing something. Examples can be seen in campaigns for Mothers Against Drunk Driving, anti-smoking advertising, and other public service ads. Utilizing these negative emotions can also be effective in retail advertising. "Act Now, Sale Ends Tomorrow" is clearly trading upon the fear of missing a great deal.

Now that we understand the "Elements of Persuasion" we are ready to move on to the next task of the persuasion partner: Determine the purchase process for the given product or service.

Understanding the Purchase Process

The purchase of every product or service involves a number of different stages or steps through which the consumer must go. Sometimes this process is very simple and very quick. Other times—as with expensive durable goods such as automobiles and houses— this process can be very complex and last up to six to twelve months.

It is the job of the persuasion partner to map out the total purchase process cycle involved in the use or purchase of this product or service and understand the different persuasion tasks involved in each area of this purchase process. The first task is to understand the purchase process and determine—at each stage in this process— what the consumer needs to progress to the next phase in the purchase process.

The traditional purchase model or funnel starts with awareness and moves through consideration to intention to shopping to purchase. This purchase process can also be represented as a cycle in which the goal is to get the consumer to return to the beginning of the cycle. It is important to understand that as the consumer advances through the purchase cycle, he or she is required to make greater and greater levels of commitment at each step. "Considering" a product requires a greater level of commitment than merely being "aware" of it. "Intending" to buy something requires a greater level of commitment than merely considering a product as one of several alternatives.

It is critical to understand this concept of increased levels of commitment because the persuasion partner must constantly ask, "What can I tell or show consumers that will permit them to make a greater commitment toward my product or brand?" The key issue of persuasion is about *moving people from indifference (or negative) to greater and greater levels of emotional and intellectual commitment.*

A thorough understanding of this concept of commitment is critical to create effective persuasion. It is obvious that different products (or services) require different levels of commitment. For example, the decision to buy a house requires a much greater commitment than does the decision to buy a candy bar. But what some people fail to realize is that each and every single step in the purchase process requires a slightly greater level of commitment—either emotionally or intellectually or both.

Understanding the Persuasion Task in Each Phase of the Purchase Process

In order to understand what tool should be used in each phase of the purchase process, one must first determine the business problem at each phase in the process. This process is like a chain that is only as strong as the weakest link. Where are the strengths and weaknesses? Is the problem in the awareness stage, the consideration stage, or the shopping stage? Each of these problems requires a different tool. Just as you wouldn't use a wrench when you need a screwdriver.

Determining the Credibility of the Brand

We have already discussed the importance of credibility. The next major task of the persuasion partner is to determine the current credibility and likeability of the brand. The persuasion task for Audi was different (and more difficult) after the *60 Minutes* segment on unintended acceleration. The persuasion task for Suzuki was much greater after the "rollover" problem was revealed. And the persuasion problem for Jack In The Box will be much greater now that their food has been labeled unsafe in the media.

The problem with George Bush wasn't his performance. It was that he allowed his credibility with the American people to deteriorate. In less than twelve months, Bush went from being the most popular (and credible) president to becoming an ex-president. This happened because he didn't pay enough attention to his credibility quotient. He thought his performance in international affairs and other areas could overcome the minor problem he perceived with the economy.

Ross Perot might have been a serious contender in his first-time presidential bid if he had not made decisions which undermined his credibility. His biggest mistake, of course, was in dropping out of the campaign in May. His credibility

was destroyed in an instant. Even with $60 million and some very effective persuasive infomercials, he was never able to regain his credibility.

One of the most tangible ways to understand the importance of credibility is to think about it in terms of your own personal job security. If your credibility with those above you starts to wane, look out. Credibility—the willingness to believe in someone—is much more important than actual performance. If your credibility is high, you can make a mistake and even fail, and people will give you another chance because they believe in you. On the other hand, if your superiors don't believe in you, you may not even get a chance to fail.

In order to be persuasive, it also helps to be likeable. In fact, according to the Gallup polls—during the past thirty years of presidential elections, likeability has been the one single element (not issues; not party affiliation) that has been absolutely and positively correlated to predicting the winner.

It is the job of the persuasion partner to assess the credibility and likeability of the company, the brand, and the products before he or she starts developing any type of communication plan.

Determining the Personality of the Brand

The next task of the persuasion partner is to determine both the current personality and the desired personality for the brand. Advertising can be thought of as "the clothes a brand wears." Before you design the clothes for the brand, it is critical to determine whether you're dealing with someone who should be wearing a Brooks Brothers suit or the latest Armani or Bijan fashion. In many ways,

the persuasion partner needs to act like a fashion consultant. Knowing the true character and personality of the client and then fitting him or her out in clothing that enhances who they are; not something that tries to make them something they're not. Some agencies are guilty of this sin. They try to put an Armani suit on a client that for twenty-five years has been dressing in traditional, conservative clothes. It doesn't work. The brand doesn't feel comfortable in its new clothes and it shows.

Developing a Fully Integrated Persuasion Plan

Once these four tasks have been accomplished, the persuasion partner is ready to develop a fully integrated persuasion plan to address these issues. Whom do you need to persuade? At what stage in the purchase process are they? What can you tell them that will persuade them to think more favorably about your brand or product?

Now you are ready to apply the specific communication tools. Each communication tool (PR, general advertising, regional marketing, promotions, and direct marketing) should be given a specific role. For example, the role of public relations might be to predispose consumers to have a favorable opinion about a product or brand by providing them with information from a more credible, third-party source. You might try to target this activity to the awareness phase of the purchase cycle.

Let's summarize the five major tasks of the persuasion partner:

1. Determine the purchase process for the product or service
2. Determine the persuasion task for each stage of the purchase process
3. Determine the credibility of the brand
4. Determine the personality of the brand
5. Develop a fully integrated persuasion plan

In the past twenty years, Tom Patty, president and worldwide Nissan account director, has helped TBWA Chiat/Day grow from a small creative boutique to an international agency with $2.5 billion in billings. Patty has consistently run and managed the largest accounts at the agency and has been involved in creating some of the most effective and the most famous advertising campaigns in the country, from Yamaha motorcycles, to Nike, to Pizza Hut, to Nissan. In the past nine years, Tom has led the Nissan account from $150 million in U.S. billings to more than $800 million in billings on five continents and fourteen countries.

Proactive Marketing

 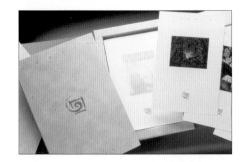

In the earliest phases of building a relationship, direct marketing proactively anticipates the needs of its audience, sending clear messages to targets with whom there is often little or no prior contact. While such initial exchanges are often the least demanding, they must, nonetheless, push for a tangible response.

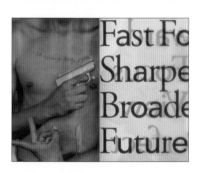

Section

Chapter 1

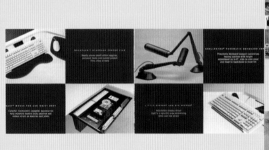

Increase Awareness

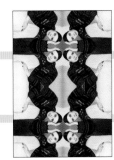

Direct marketing to increase awareness works best when the basic act of sending a message is the primary goal. Closest to traditional advertising, it is the least tangible use of the power of direct marketing to elicit a response, and hence opens this book.

The category contains many simple, elegant messages whose ephemeral nature is part of their appeal. Often arriving in the form of an announcement that is a stand-alone piece, this level of direct marketing informs and educates the recipient—with success measured by how well the message is retained. Here, exposure and a creative twist are the ideal marketing and design equation for getting the concept across: an equation that the Eagle's Eye image book has used with stunning effect.

EAGLE'S EYE, A NEW PERSPECTIVE

THE DESIGN TEAM

CLIENT | **EAGLE'S EYE**
DESIGN | **SOCIO X**
Creative Director | **DEBORAH MOSES**
Art Director | **BRIDGET DE SOCIO**
Designer | **ALBERT LIN**
Photographer | **RUVEN AFANADOR**
Digital Imager | **NINJA VON OERTZEN**

The soft fleece of wool sweaters stands out in luxurious contrast to the stiff mylar cover, metallic divider pages and mirrored images. All transparent layering and optical effects, the Eagle's Eye image book is page after sumptuous page of chic classic clothes for an emerging fashion brand in search of credibility. A classic apparel company with modest beginnings about twenty years ago, Eagle's Eye has grown into a multi-million dollar operation. As garment marketers turned their focus once again to the power of brands, the company made a strategic decision to create a new "look" for Eagle's Eye that would take the business from manufacturer to brand name. They wanted to send the message that Eagle's Eye is different. It is changing. The resulting upscale image book, designed by New York-based Bridget de Socio of Socio X and

photographed by Ruven Afanador, builds awareness among ready-to-wear buyers by inviting them to take a fresh look. But the book also embodies some of the vulnerabilities direct marketers face when they focus on image over action. Effective direct marketing must change behavior, not attitude. It must do more than send a message. It must persuade.

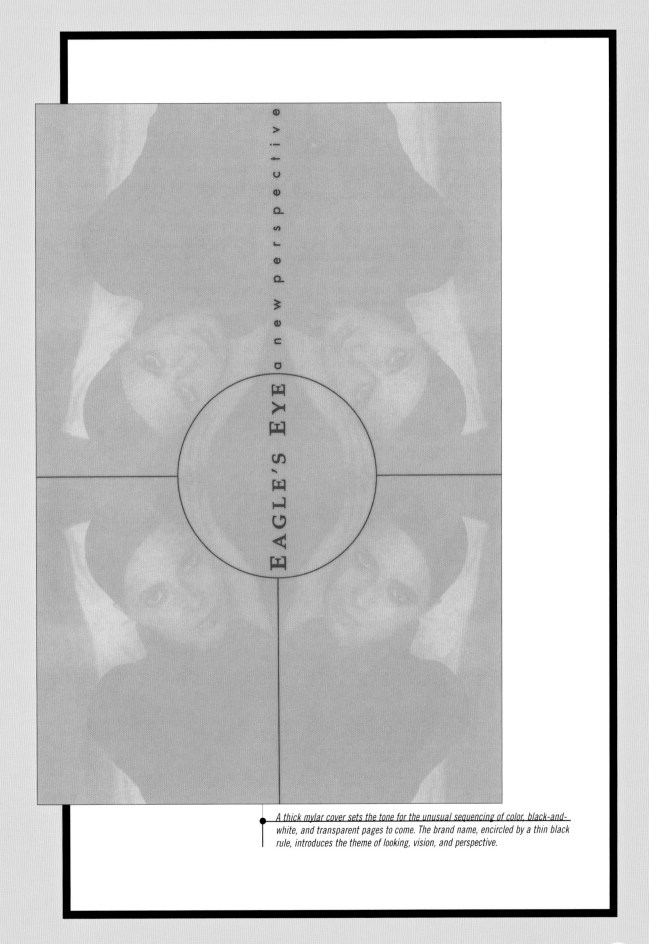

EAGLE'S EYE a new perspective

A thick mylar cover sets the tone for the unusual sequencing of color, black-and-white, and transparent pages to come. The brand name, encircled by a thin black rule, introduces the theme of looking, vision, and perspective.

With a target audience of three-thousand department and specialty store buyers, the client wanted something impressive. "They wanted a memorable, knock-your-socks-off object. They wanted a big, substantial, heavy book," de Socio recounts. It had to be weighty with the message that Eagle's Eye has a new perspective. De Socio began by asking questions—What can be said that is new about the whole act of looking? Since her graphic design studio also does digital imaging, the answer quickly became clear: the design magnifies, flops, mirrors, and repeats images until in some cases they become like patterns on an Indian blanket. The book was produced at breakneck speed, and the images have a lot to convey. "The kaleidoscopic use of layered images is very much about digital technology, about being in

a directionless space. It comes out of the way we think about how we live now."

But the book is mostly about fashion and puts forth its own distinct point of view: Classics are about multiples, the same things in new ways. Couture is about singularity. "No matter what you combine classics with, they work, and the book was meant to have the same flexibility," explains de Socio. "You can look through it from back to front, upside down, and it still works. It is nondirectional like classics, which are seasonless."

In the quiet refinement of the nineties, image books have emerged as one of the key communication tools fashion brands use to enhance their credibility. Donna Karan, Ralph Lauren, Giorgio Armani and Calvin Klein have all

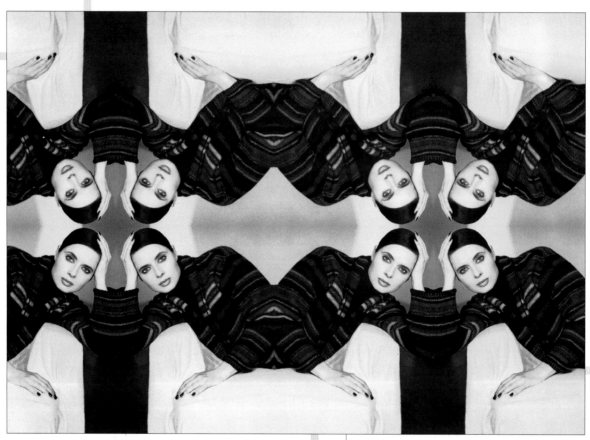

The relationship between patterning in garments and patterning in imagery is communicated through the pacing and sequencing of the book. By alternating close-ups of sweater designs with photographs whose compositions echo shapes on the preceding or following pages, a kaleidoscope of color and form is revealed.

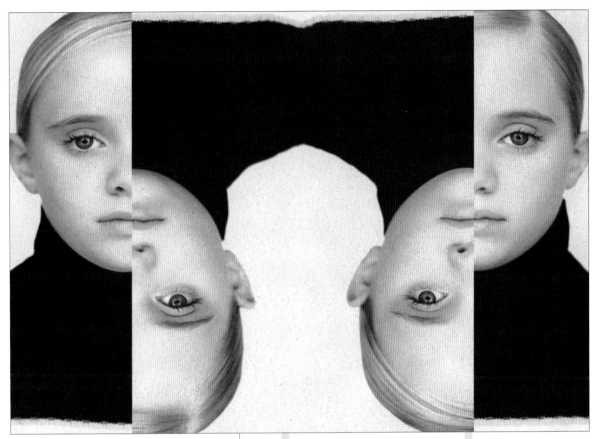

Rather than appearing disjointed, de Socio's sensual
approach to color and layering allows intentionally split
and flopped images to take on a new dimension that
lures the reader further into the book. Transparent vellum
brings a welcome contrast in texture to the polished
finish of opaque silver divider pages.

produced highly targeted image books to keep the unique positioning of their brands alive, and to wrap a visual narrative around their products' assets. From these carefully created pictures, stories are woven that speak to the target audience—to their tastes and values—helping to generate awareness, the first step in forming an emotional pact between the consumer and the product.

Awareness is the least tangible response direct marketing can be expected to deliver. While few marketers doubt the power of a well-executed campaign, most success stories are the accumulated result of multiple impressions, repeat exposure. Eagle's Eye dared to create a graphically intense direct mail piece, but its esoteric splendor does little to enlighten the audience about who the brand really is.

The type is so discrete as to be non-existent, so images like those of Isabella Rossellini lounging on a sleek modern sofa in a downtown loft carry most of the weight. The contact information requires a hunt. It may be that a statement from the owners and a reader response card could have defined the book's purpose more clearly and guided the reader through the brand positioning—allowing the nuances of the visuals to coalesce around the idea.

Focus on establishing a synergy between the product, the offer, the design, and the audience. The trick is for all these elements to mutually reinforce a single core message. If one component is out of sync, it jeopardizes the entire structure.

The success of an awareness campaign can be judged by how well the brand name is recalled in the weeks following the mailing, and by the recipient's openness to a sales call.

Nature loves to repeat herself and, inevitably, the duplicating and reassembling of images results in soothing, abstract shapes that nonetheless have their suggestive side. The client made a daring move to allow such undercurrents of sexuality to remain—and to capitalize on the sexual spin fashion has often used to draw attention to itself.

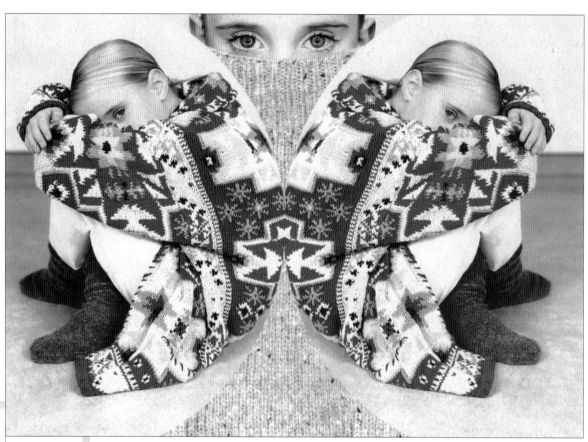

The playful and powerful repetition of key shapes is balanced by the classic decorativeness of the garments themselves. The wisdom and beauty of this approach is that it also subtly reinforces the flexible nature of classic clothes, a concept the audience can understand. It's also a key selling point for the company, which may have been communicated too subtly.

The book has a kind of modern luxe perfectly suited to where fashion is headed next. De Socio's mix of downtown hip and uptown polish combines to produce an intriguing exploration of visual space that may say little about sweaters and pants but says a lot about shaking up the way we look at a fashion brand. Then there is the undercurrent of sexuality that runs through the book. The cutting and splitting of the images form explicit shapes that imply that sex, design, and persuasion are well acquainted.

"I think all designers try to push the envelope when they are designing and, yes, sometimes we ask ourselves 'Is it too far? Is it too advanced? Did it go past the audience?' But we know we are going to get pushed

back from the client. In this case, they didn't push back. Actually, we toned down some images that we thought went too far and were surprised that they left others in that we probably would have taken out."

The geometry of classic dressing is ingeniously repeated throughout the book, reinforcing the connection between the concept, the product, and the design. De Socio knits rich color throughout the layouts and builds a dynamic between pages by interspersing magnified sections of the garments with sheets of deep blue—a color that says "classics."

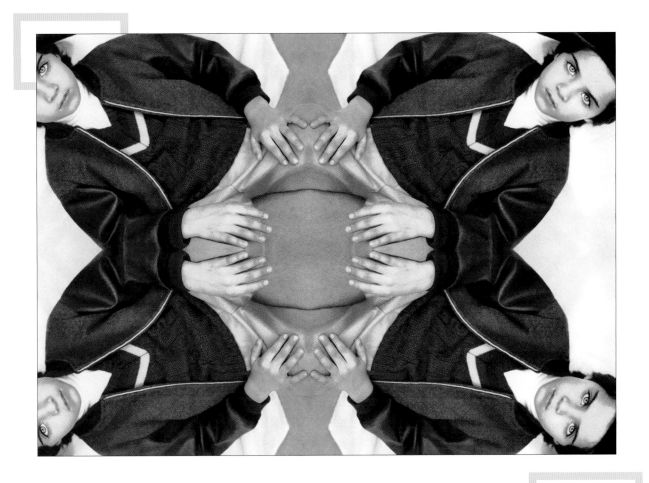

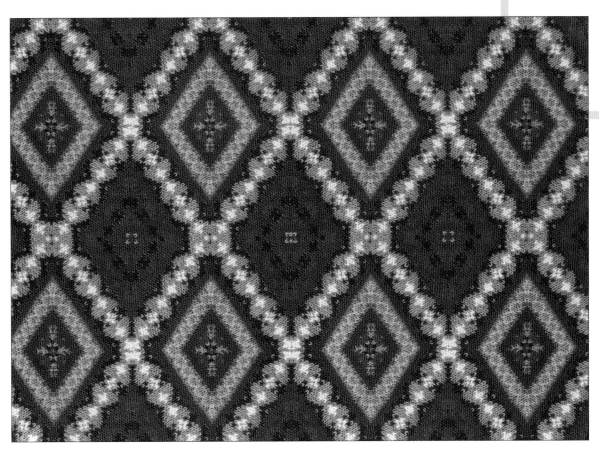

Increase Awareness

Client: **Tony Stone Images**
Design: **Concrete**
Designers: **Jilly Simons, David Shields, Susan Carlson**
Copywriter: **Chuck Carlson**

This small book, filled with vellum pages and bold head-line text that carries from one spread to another, announces the acquisition of AllStock (a Seattle-based stock photography agency) by Tony Stock. The response postcard encourages the user to request a catalog.

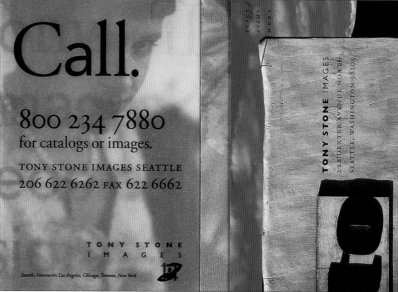

Call.

800 234 7880
for catalogs or images.

TONY STONE IMAGES SEATTLE
206 622 6262 FAX 622 6662

TONY STONE
IMAGES

Seattle, Vancouver, Los Angeles, Chicago, Toronto, New York

TONY STONE IMAGES
2212 DEXTER AVENUE NORTH
SEATTLE WASHINGTON 98109

Client: **Knoll, Inc.**
Design: **Boxer Design**
Designers: **Eileen Boxer**
Baker: **Cheryl Kleinman Cakes**

Once they found someone able to bake the necessary amount of cookies, modernist furniture company Knoll, Inc.'s delectable holiday card quickly took shape. The skinny Knoll *K* on the plump white cookie helps reinforce the company's corporate identity and makes it part of a total graphic system. And yes, eating the offer is a tangible response!

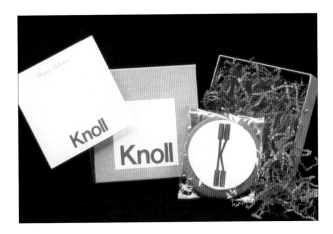

Client: **Knoll, Inc.**
Design: **Boxer Design**
Designer: **Eileen Boxer**

This sleek direct mailer for Knoll Extra organizes photographs in a modernist grid to show off the "extras" available from this venerable contemporary furniture manufacturer. Acid background colors—like bright yellow and chartreuse—make the predominantly black products stand out, while the palette speaks in a contemporary voice to a targeted, design-conscious audience.

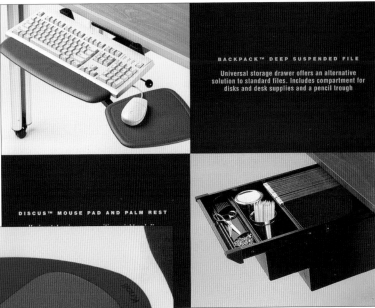

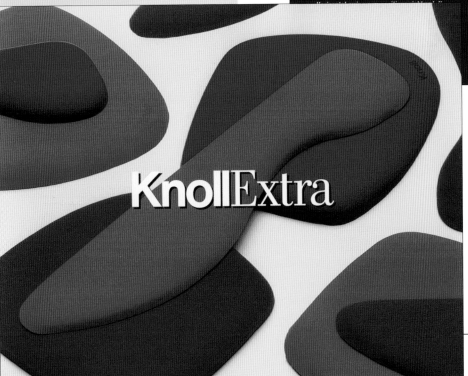

Client: **Corbis Corporation**
Design: **Hornall Anderson Design Works, Inc.**
Art Director: **Jack Anderson, John Anicker, David Bates**
Photography: **Corbis archive**

Designed for Corbis, the world's largest digital collection of fine imagery, a tri-fold kit opens with a letter from the president explaining the company's service, benefits, and a short-term special price offer. A small collection of individual cards comes protected in vellum and contained in its own box—reinforcing the idea of an art portfolio.

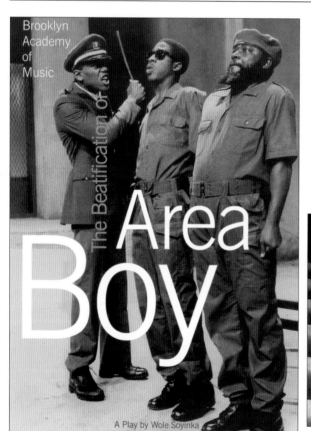

Client: **Brooklyn Academy of Music**
Design: **BAMdesign**
Designers: **Rafael Weil, Jason Ring**
Photography: **Corbis archive**

The Brooklyn Academy of Music specializes in innovative and daring performances, a fact that makes it a cultural institution particularly in need of effective communications. Individual postcards highlighting unique events are part of an integrated plan that builds awareness and prompts those who have already received the catalog to purchase tickets.

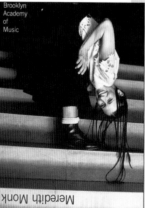

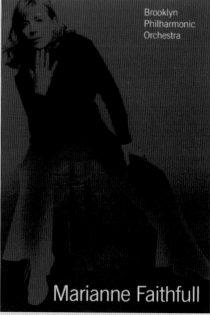

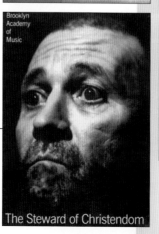

Client: **Brooklyn Academy of Music**
Design: **BAMdesign**
Design Consultant: **Michael Bierut**
Art director: **Rafael Weil**
Designer: **Jason Ring**
Photographer: **Brigitte Lacombe**

A leap from academic, "coffee table book" to kinetic magazine format, this promotion for the Brooklyn Academy of Music's *Next Wave* Festival creates a strong new voice that welcomes the public and articulates the energy of this performing arts institution.

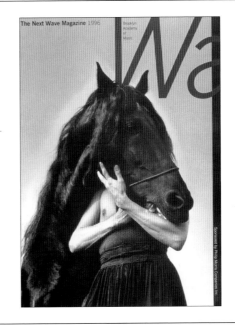

Client: **Brooklyn Academy of Music**
Design: **BAMdesign**
Design Consultant: **Michael Bierut**
Art Director: **Rafael Weil**
Designer: **Jason Ring**

Created to market this Brooklyn Academy of Music production and its unique performance troupe to a first-time audience, this brochure pays special attention to the images of horses in the show. The "horse lovers" mailing includes a removable ticket order form; the rest of the brochure becomes a poster-sized reminder of the show and an enticement to mount it publicly for additional exposure. The mailing helped BAM reach more than one hundred percent of its overall sales goal.

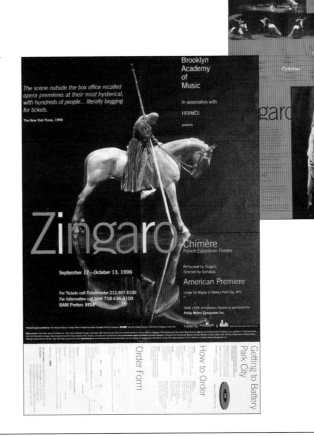

The Brooklyn Philharmonic Orchestra
Robert Spano—conductor
Pilar Rioja—dancer
Carmen Linares—cantaora
Flamenco guitarists

Turina *Oraja", La oración del torero"*
Roberto Gerhard *Alegrías*
Carlos Surinach *Sinfonietta flamenca*
Traditional flamenco music †
Falla *Three Popular Songs* †, *El amor brujo*†*

* with Pilar Rioja
† with Carmen Linares

BAM Opera House
Friday & Saturday, March 7 & 8 at 8pm
(pre-concert presentation with Robert Spano and guests at 7pm)

Tickets: $35, 27.50, 20, 15

Sunday Interplay
Pilar Rioja—dancer
Carmen Linares—cantaora
Robert Spano—conductor
Martin Soderberg—piano
BPO chamber musicians
Spanish flamenco artists

BAM Carey Playhouse
March 9 at 2pm
Tickets: $20, 10

For program information call 718.636.41...

Federico García Lorca called
flamenco "the most gigantic
creation of the Spanish
people." As the latest in its
series of gala BAM week-
ends exploring the folk
roots of concert music,
the **Brooklyn Philharmonic
Orchestra presents
Flamenco,** featuring leading
flamenco authorities, singers,
guitarists, and dancers.
The weekend's special
guest artists are **Carmen
Linares,** one of Spain's
supreme contemporary
exponents of *cante jondo*,
in a rare North American
appearance, and **Pilar Rioja,**
appearing in concert with
full orchestra for the first
time in New York.

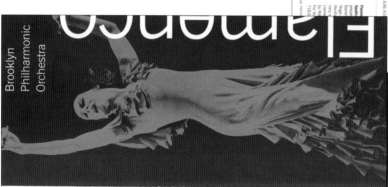

Brooklyn
Philharmonic
Orchestra

Pilar Rioja

"As real greatness as one has seen in
Spanish dance in some time."

Carmen Linares

30 Lafayette
Avenue
Brooklyn NY
11217-1486

Brooklyn
Philharmonic
Orchestra

NON PROFIT
ORGANIZATION
US POSTAGE
PAID
Brooklyn NY
PERMIT #7368

Client: **Brooklyn Philharmonic Orchestra**
Design: **BAMdesign**
Art Director: **Rafael Weil**
Designer: **Jason Ring**

This slim direct mailer was developed as a reminder to
flamenco enthusiasts who also receive the season brochure
highlighting upcoming performances and how to purchase
tickets. Although dramatic in appearance, the mailer was
economically produced using only two colors throughout.

Client: **Benefit Promotions**
for Champion International Papers
Design: **Drenttel Doyle Partners**
Art Director: **Stephen Doyle**
Designer: **Stepanie Rehder**

An elegant old-fashioned photo album is relieved from any
possible stuffiness by modern touches: grommets and
cord, a jazzy plaid cover that works with the company's
visual identity, and a cleaned-up label design. From
collecting to packaging to archival documentation, "Benefit
papers are far more than just writing paper" is the
persuasive message of the packet.

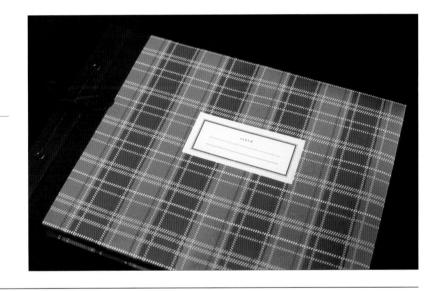

Client: **Benefit Promotions**
for Champion International Papers
Design: **Drenttel Doyle Partners**
Art Director: **Stephen Doyle**
Designer: **Katrin Schmitt-Tegge**

In a handsome raffia-filled box, a pair of green candles
comes wrapped in a soft gray label printed with the note
2 Candele d'Amore, perfette per tutte le occasioni romantiche,
and the announcement of four new magnificent colors
from Benefit paper. Candles, an unusual choice for a paper
promotion, reinforce the multiple uses of paper for pack-
aging, appeal to an audience concerned with quality, and
encourage recipients to save the piece–which, in turn,
reinforces a relationship with the brand.

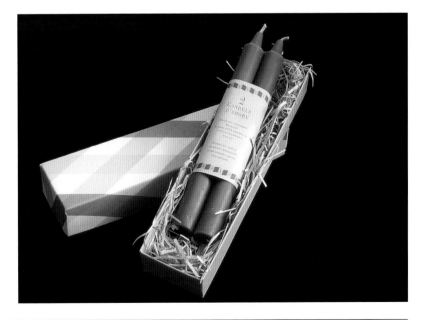

Client: **Benefit Promotions**
for Champion International Papers
Design: **Drenttel Doyle Partners**
Art Director: **Stephen Doyle**
Designer: **Cary Murnion**

Sophisticated neutral shades of green, gray, and gold define the Champion Paper identity. A direct mail campaign to increase awareness concerning the papers and their uses carries the signature color scheme into the design of an "antique" map. Upon closer inspection, each element of the map demonstrates the attributes of Benefit for Champion. The compass rose, for example, is a color wheel. The minuscule type is legible only with a magnifying glass, accompanied by a small compliments card and an 800-number. Repeat, high-quality, well-targeted mailings produce an ongoing awareness that builds a relationship with the audience.

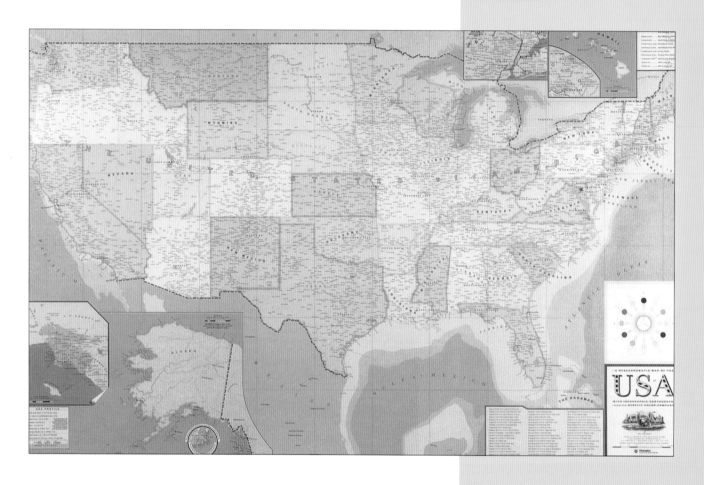

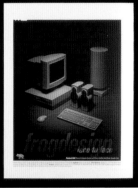

propaganda

eleven reasons to choose frogdesign

Client: **frogdesign**
Design: **frogdesign**
Arbiter: **Hartmut Esslinger**
Creative Directors: **Steven Skov Holt, Gregory Hom**
Art Director: **Gregory Hom**
Editorial Director: **Steven Skov Holt**
Senior Designers: **Matthew Clark, Eddie Serapio**
Designer: **Thomas Preston Duval**
Guest Editor: **Phil Patton**
Photographers: **Hashi, Dieter Henneka, Steve Moeder, Sysop Craig Syverson**

A visually overloaded promotional brochure-magazine from
the innovative industrial design firm frogdesign, offers the
firm's point of view on everything from the environment to
cultural trends. It also includes a history of the firm's
work since 1969. Strategically placed ad pages sell only
frogdesign products and services. The techno-aesthetics
and information-packed pages may not be for every prospect,
but they convey strategic and design credibility for the
California-based firm—while bringing together a diverse
collection of voices on topics of relevance to their client base.

Chapter 2

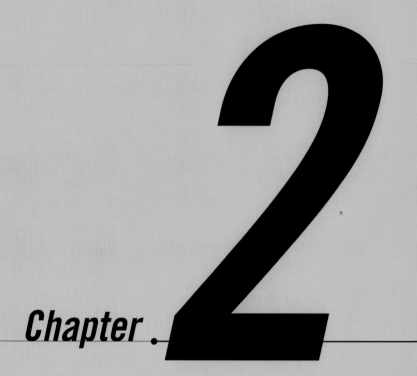

Build a Relationship

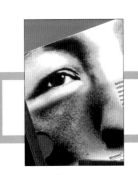

What arrives in the mail has a distinct influence on the public's exposure to and awareness of graphic design.

While, apart from postal stamps, only a small percentage of what is mailed would truly rate as well designed, the vast number of invitations sent out daily fill every conceivable description, from minimal to lavish, predictable to surprising, formal to outrageous. What links them all is a cry for involvement. A seamless integration of image and content may be the main ingredients of any creative solution, and only a marketer/designer with skill and experience can elicit a response from the recipient, the true litmus test of any direct mail offer.

FOR KEEPS: UBU GALLERY

THE DESIGN TEAM

CLIENT — **UBU GALLERY**

DESIGN — **BOXER DESIGN**

Art Designer/Designer — **EILEEN BOXER**

Consultants — **JACK BANNING,**

ADAM BOXER,

ROSA ESMAN

What sort of art gallery would send out invitations that are as surprising and covetable as anything they might exhibit? The answer, in two words, is Ubu Gallery, which at its offbeat location on Manhattan's Upper East Side demonstrates that it is no less committed to disruption than it is to selling avant-garde photographs, paintings, and sculptures from the twentieth century. Their witty and expressive invitations display an attribute rare in the often prima-donna world of graphic design: a willingness to relinquish the hand of the designer for the sake of the artist on view.

With that approach, the collaboration among three New York gallery directors, Jack Banning, Adam Boxer, and Rosa Esman, and graphic designer Eileen Boxer has resulted in a series of direct mail pieces intended to condense the guts of an exhibition into an invitation. In a spirit akin to the witty conceptual work of French Dada artist Marcel Duchamp, who claimed it was "always the idea that came first, not the visual example," Eileen Boxer pursues a path that is as graphically simple as possible. In Boxer's view, "To be too designy would take away from the concept of these pieces. In certain cases they are even under-designed. They are not prime examples of precious typography, but intentionally non-decorative to make them substantial. They go under the skin, which allows them to live with you longer than a pretty face would."

*This small, humble container for the exhibition "The Box: From Duchamp to Horn"
simultaneously captures the spirit of the show and invites the recipient to
become involved when it arrives as a box to be assembled.*

True to its quirky European name, the invitation to a show about the 1938 Exposition Internationale du Surréalisme *focuses on a life-sized mannequin designed to be a punch-out, stand-up cardboard doll. The required assembly invites users to interact with the piece, which takes their involvement with the gallery to a new level.*

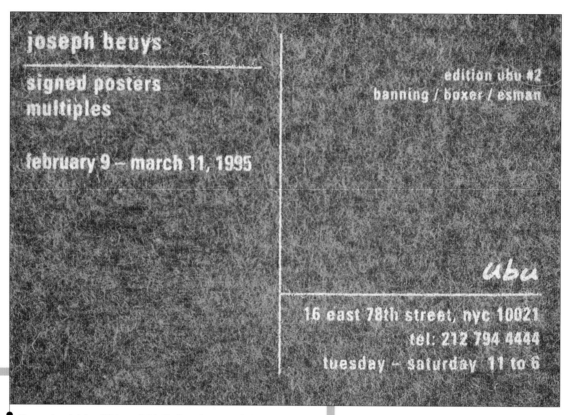

joseph beuys
——————————————————————
signed posters
multiples

february 9 – march 11, 1995

edition ubu #2
banning / boxer / esman

ubu

16 east 78th street, nyc 10021
tel: 212 794 4444
tuesday – saturday 11 to 6

Typography printed on thick gray felt in the form of a postcard gives an unusual impression of permanence to the typically ephemeral gallery invitation, in this case for the show "Joseph Beuys: Signed Posters + Multiples." Beuys often used felt in his work, which further ties the invitation to the art.

Bent on subverting expectations, Adam Boxer delights in telling how he discovered that the invitations were not being tossed but saved by the very audience he sought to attract. "A month after our second exhibition I was visiting Sandra Philips, a photography curator at the San Francisco Museum of Modern Art. I noticed that in her office she had saved the box that served as the announcement for the opening. I wondered to myself, 'Now why would a photography curator keep a gallery announcement like that when we aren't a photography gallery?' Then it hit me. We were on to something." That something also moved a Toronto gallery dealer to confess "I only look for two things in the mail: checks and Ubu announcements." The story of Ubu's unusual, engaging relationship-building mailings had begun.

The gallery's fifth show, for example, was an homage to the *Exposition Internationale du Surréalisme* held in Paris before the outbreak of World War II. In typical Surrealist fashion, the invitation displays a photograph of a female mannequin on the front. Naked, except for a small tufted heart coyly placed between her legs, she peers out through the open door of a birdcage that covers her head like a giant fencing mask. Her curvaceous form, outlined by a perforated border and an extendible arm adhered to the back of the card, can be transformed into a stand-up doll. The image of the mannequin lifted from the original 1938 show establishes a historical link to Ubu's contemporary version. It also builds a visceral connection between the recipient and the gallery through the tactile construction of the doll.

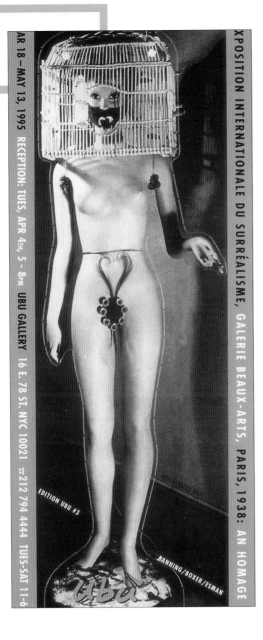

The adventure of text on a page is taken to new levels with the invitation to the show, "Helmut Lohr——Visual Text." Translucent paper both covers and reveals individually cut and hand-stamped book pages chosen by the artist.

All successful direct mail must generate an immediate tangible response; a delay increases the failure rate. The response to an invitation is tangible in a few ways: retention (how often an invitation is saved rather than discarded), recency (shortening the time span between visits or use), and frequency (increasing the total number of visits or use).

Among Eileen Boxer's more celebrated solutions is the invitation to a show of Yoko Ono's drawings and Blood Objects. Boxer solicited the artist's input on the selection of an object to include in the mailer, requesting that it be light, flat, and easily mailable. "All Yoko said was a key. And she gave us the cadmium red paint. The Blood Objects are about a traumatic experience so we re-created the idea of a police specimen with the key, a tag, and a Ziploc bag," Boxer recalls. They hunted for old house keys to get a rich, worn patina and to ensure the uniqueness of each piece. Hand-dipped in the flaming paint, the keys replicate the eerie sensation of Ono's art.

The gallery's direct mailings largely succeed through their unusual approach to sampling. Had Eileen Boxer simply reproduced the art on view, the designs would hardly have elicited such a remarkable response. Instead, her invitations mementoize each exhibition, creating the impression of actually possessing one of the works on display in the form of a printed or assembled object. By capturing the spirit of the artist's work, Ubu combines the rational and the emotional in one direct marketing device. "The aim is to take the key note of the exhibition and represent that in the invitation," says Boxer. "The invitation involves the artist intimately. When people receive it they get a clear, one-two punch of who the artist is. The work sets the tone. We are just extrapolating it." One example is the work of artist Hans Bellmer. Bellmer was fascinated by two life-sized female dolls, which he created and photographed between 1934 and 1938 in various poses, triggering

The cadmium-dipped objects in specimen bags used to alert visitors to the opening of "Yoko Ono: Drawings from Franklin Summer and Blood Objects from Family Album." are exemplary of the gallery's commitment to faithfully interpreting the artist's work rather than choosing a more commercial

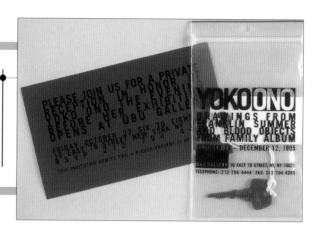

For this poster announcing the show "The Gun: Icon of Twentieth Century Art," the artist, Tom Sachs, shot 100 sheets at a time with a Glock 9mm gun to add the final design detail—real bullet holes.

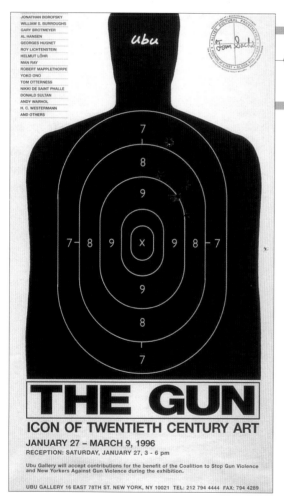

Designer Eileen Boxer exerted her own aesthetic as little as possible by playing with the design for a sheet of actual press-type to create an invitation to the show "George Maciunas: More than Fluxus, graphic design, objects, ephemera."

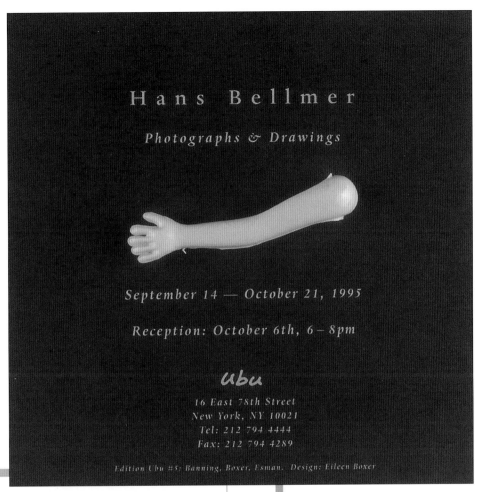

A small doll's arm glued to the surface of the invitation introduces the viewer in a tactile way to the oddly juxtaposed, sexually charged photographs and drawings of the artist Hans Bellmer.

references to sexuality, passion, and desire. To produce a fragment of Bellmer's artistic world, a tiny plastic doll's arm was carefully glued onto a square black card so that the detached appendage floats within a small pool of darkness. Exhibition specifics reproduced in pink type communicate the shock appeal of his work.

For a sophisticated art world audience, each concept has to be smart, not gimmicky. "People brush off cuteness but if a piece is really thoughtful then you can speak to everybody in ways that are intelligent without going over their heads. I don't think you turn people off by appealing to a higher average," Eileen Boxer explains. For a mixed-media show exploring the paradox of associations around guns, a poster-sized invitation modeled

on a target was shot with a handgun by Tom Sachs, one of the participating artists. The random ripping of the paper by the bullets dramatizes the message and records the moment in which the piece was made. To assuage concerns about the gallery's politics, the mailer included a contribution form to benefit the Coalition to Stop Gun Violence and New Yorkers Against Gun Violence.

An invitation that requires assembly takes the degree of involvement to an active level of participation. Ultimately, these tactics seek to move the recipient beyond involvement and participation to commitment, the foundation of a rewarding relationship.

PIERRE MOLINIER
(1900 - 1976)

UBU GALLERY		WOOSTER GARDENS & BRENT SIKKEMA
SEPTEMBER 7 – OCTOBER 22, 1996		SEPTEMBER 7 – NOVEMBER 9, 1996
RECEPTION: WEDNESDAY, OCTOBER 2ND 5-8 PM		RECEPTION: SATURDAY, SEPTEMBER 7TH 6-8 PM
●		●
16 EAST 78 NEW YORK 10021 TEL: 212 794 4444 FAX: 794 4289		558 BROADWAY NEW YORK 10012 TEL: 212 941 6210 FAX: 941 5480

FETISH PERFORMANCE PHOTOGRAPHS, COLLAGES, PHOTOMONTAGES

EDITION UBU #9 BANNING / BOXER / ESMAN DESIGN: EILEEN BOXER

The invitation to a show on French performance artist Pierre Molinier seemed appropriately suggestive and rich for an art that includes fetish objects. Each invitation came wrapped in an actual black silk stocking with the artist's name printed in gold.

In strong direct mail, concept is the bait, execution is the hook. For the photographic works of Pierre Molinier (1900–1976), the influential French gender performance artist, "We gave people a stocking. Finding real stockings, though, and getting them printed cheaply and well with Molinier's signature was critical and a huge chore." The effect, though, is undeniable. An illicit anticipation builds as the printed card is revealed beneath the silky black lingerie, suggesting the intimate, fetishistic act of exploring the contents of a woman's underwear drawer.

All successful direct mail must generate an immediate tangible response, since any delay decreases the rate of success. While it is unlikely that most people will open their mail, throw on their coats, and dash over to the gallery, Ubu's tactile inducements nonetheless initiate and sustain a compelling dynamic between the recipient, the artwork, and the gallery. Many of their relationship-building strategies are erroneously considered to be intangible. In fact, a response can be tangibly tracked in a few ways. The number of invitations kept rather than thrown away measures retention. Recency is evident in how short a time span occurs between visits. The increasing total number of visits that a recipient makes to the gallery gauges frequency.

All these measures are the result of precise involvement tactics. Hidden messages engage the viewer in a closer study of the piece. Invitations that require assembly encourage participation and discovery. Such stimulants move the recipient beyond involvement to investment—the foundation of any meaningful relationship.

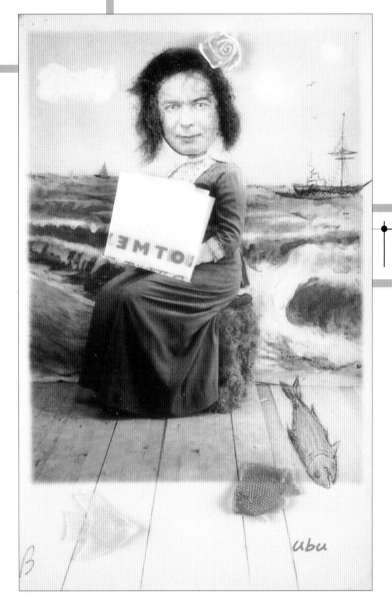

The invitation to *"Gary Brotmeyer: Thanks for the Fish!"* sets the theme for an exhibition of collages created from vintage photographic portraits adorned with small objects. The message is a folded-up note inserted in the image as an object within the design.

The invitation for *"The Subverted Object"* fulfills the exhibition's title by expressly denying its function. It arrives without instructions and with the two inner pages glued together. In ripping open the center spread to get at the information, the pages tear and the message is obliterated. To the dealer's delight, several recipients phoned the gallery to inform them of a problem with the invitation!

Build a Relationship

Client: **Rebecca Moses**
Design: **Socio X**
Illustrator: **Rebecca Moses**
Art Director/Designer: **Bridget de Socio**

This square yellow invitation to preview a new luxury collection of Rebecca Moses sportswear at a gallery in Milan opens like a gift to reveal charming illustrations of a Rebecca Moses collection in free fall. Details are what make this worth spending time over: the round sticker closure printed with the initials *RM*, the printed vellum over the illustrations, the printed gray ribbon band that runs around the outside.

Client: **Rebecca Moses**
Design: **Socio X**
Illustrator: **Rebecca Moses**
Art Director/Designer: **Bridget de Socio**

The white square surrounded by a printed lavender ribbon has the fresh appeal appropriate to an opening for Rebecca Moses' Spring–Summer 1997 collection. Decorated on the inside with the designer's illustrations of pants, coats, bags, and sweaters, the invitation is cut diagonally to give the feeling of a surprise when opened. Each invitation consistently includes graphic features that communicate information about the brand, reinforcing identifying cues in the consumer's mind.

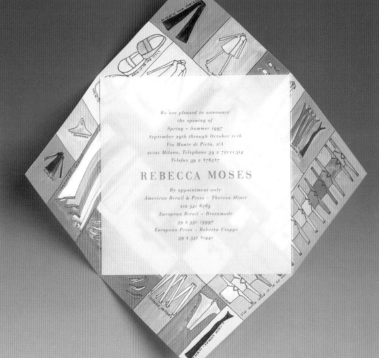

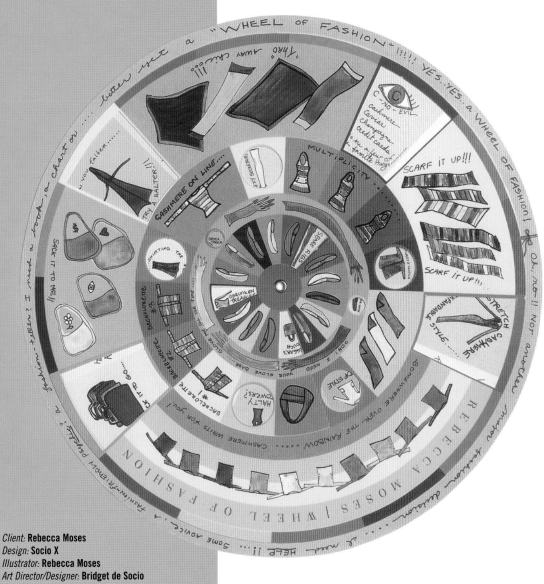

Client: **Rebecca Moses**
Design: **Socio X**
Illustrator: **Rebecca Moses**
Art Director/Designer: **Bridget de Socio**

This ingenious and engaging "Wheel of Fashion," created to alleviate the headache of getting dressed, is both witty and practical. A seemingly frivolous piece, its coordination required precise measurements and careful planning to successfully pull off the idea and win credibility from the target audience.

Build a Relationship

gallery

Client: **Tony Stone Images**
Design: **Concrete**
Designers: **Jilly Simons, David Shields**
Copywriter: **Chuck Carlson**
Photography: **Various Tony Stone Images photographers**

Bright, summery, fold-out postcards promote the use of Tony Stone images during the warmer months, a typically slow time for stock photo agencies. The collection of images is revealed sequentially, engaging the user and recalling the experience of working with transparencies in the black border around the images. These awareness-generating mailers help build a relationship by keeping clients up-to-date on company news and by promoting the stock catalog.

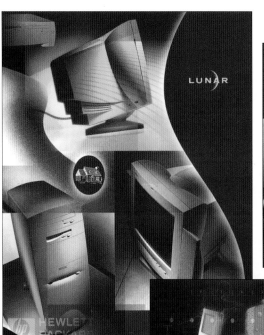

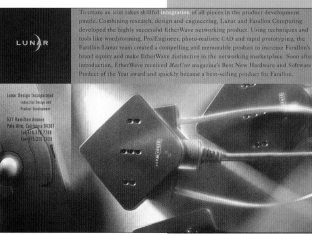

Client: **Lunar Design**
Design: **Michael Mabry Design**
Art Director/Designer: **Michael Mabry**
Photographer: **Rick English**
Design: **Post Tool Design**
Designer: **David Karam**

Every other month Lunar, a Bay Area industrial design firm, mails an oversized postcard to clients, vendors, and friends to maintain awareness and cultivate ongoing relationships, as well as to feature new products. Here, repetition is an important tactic for elevating marketing to the next level of direct response: relationship building.

Client: **Carbone Smolan**
Design: **Carbone Smolan Associates**
Photographer: **Hugh Kretschmer**

Carbone Smolan's regal-looking L'Adresse is an address-book gift for clients that's filled with great places to escape to, revel in, even sing about. Surreal or Cubist photo-collages help enliven and identify each section. Comments, like those a close friend might offer, appear beneath each address, cultivating an intimacy with the target audience through a highly personalized voice.

gallery

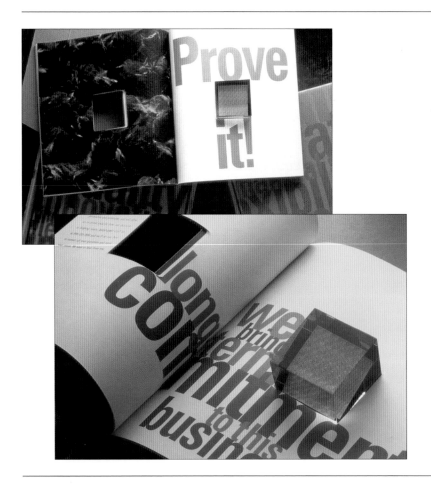

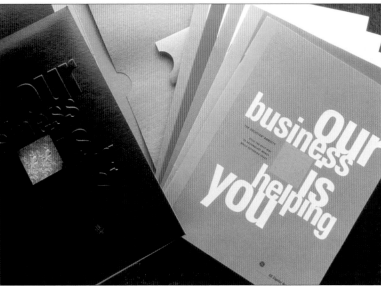

Client: **GE Capital Assurance**
Design: **Hornall Anderson Design Works, Inc.**
Art Director: **John Hornall**
Designers: **John Hornall, Lisa Cerveny, Suzanne Haddon**

To quote Oscar Wilde, who loved to create plays not just on words but expressions, "Nothing succeeds like excess." This multiple-piece mailer uses excess to its advantage to announce the launch of GE Capital, a provider of annuities and insurance that wanted to attract a select group of brokerage general agencies. The purpose was to leverage GE through a break-the-mold marketing package that communicated premium financial credibility and an innovative, service-oriented personality. The resulting tactile, three-dimensional design includes a clear acrylic cube nestled inside a book that can be kept as a desk accessory. Floating inside the cube is a magic eye GE logo, linking the company to its current advertising campaign. Textured paper, bold type treatments, and creative embossing communicate affluence and reliability.

Client: **GE Capital Assurance**
Design: **Hornall Anderson Design Works, Inc.**
Art Director: **John Hornall**
Designers: **John Hornall, Lisa Cerveny, Suzanne Haddon**

A companion piece to the launch kit that boldly communicates service through the repetitive headline, "Our business is helping you." Enclosed in this intriguing Velcro-fastened binder are a range of brochures in muted colors, each with a specific intention—be it to inform, persuade, or gather information—all a means of building a relationship.

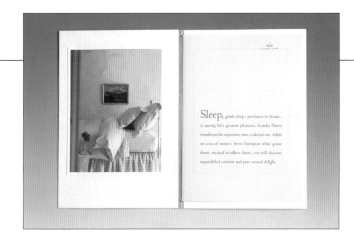

Client: **Scandia Down**
Design: **Design: M/W**
Art Director: **Allison Meunch Williams, J. Phillips Williams**
Copywriter: **Laura Silverman**
Photographer: **William Abramowicz**
Designers: **Allison Muench Williams, Mats Hakansson**

In an age of digital customization, the beauty of this brochure for Scandia Down is its simple flexibility. Since merchants in each of the 25 independent Scandia Down stores nationwide have their own ideas about which merchandise to feature, seductive postcard images of fluffy beds and linens can be selected and inserted into the brochure at will to produce customized mailings. Dreamy copy sets the tone for products associated with sleep.

Client: **Strategos**
Design: **Bielenberg Design**
Art Director/Designer: **John Bielenberg**
Photographer: **Doug Menuez**
Copywriter: **Rich Binall**

Contrary to certain schools of thought, size does matter. This 22" x 17" (56 cm x 43 cm) brochure is really just packaging for the think piece within: a corporate manifesto that to get at, the recipient must rip open a sealed plastic bag attached to the last page. Scale and tactility combine to leave an impact on the user.

Build a Relationship

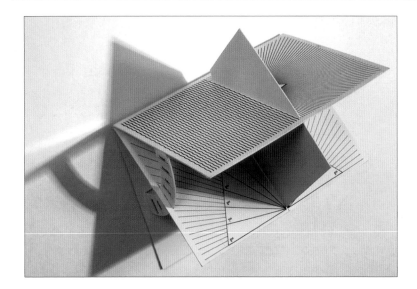

Client: **Sagmeister, Inc.**
Design: **Sagmeister, Inc.**
Art Director: **Stefan Sagmeister**
Designers: **Stefan Sagmeister, Veronica Oh**

This inventive sundial mailer can be taken as a metaphor for the elements of a successful direct mailer. It combines art and science, invites participation, can be customized to the city one lives in, folds up into postcard-size for easy mailing—and goes a long way toward reinforcing positive feelings associated with the designer and his ingenious work.

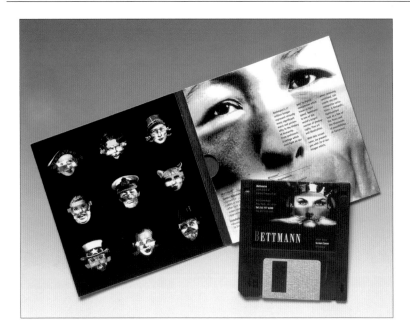

Client: **Bettmann Archives**
Design: **Carbone Smolan Associates**
Art Director: **Ken Carbone**
Designer: **Justin Peters**

Seeking to create a direct-mail holiday gift that would be visible all year long, Bettmann worked with Carbone Smolan to design a screensaver that allows 20 different portraits to be spliced and recombined into 160,000 humorous, surreal combinations. The recipient interacts with the piece, which results in an implicit relationship with Bettmann.

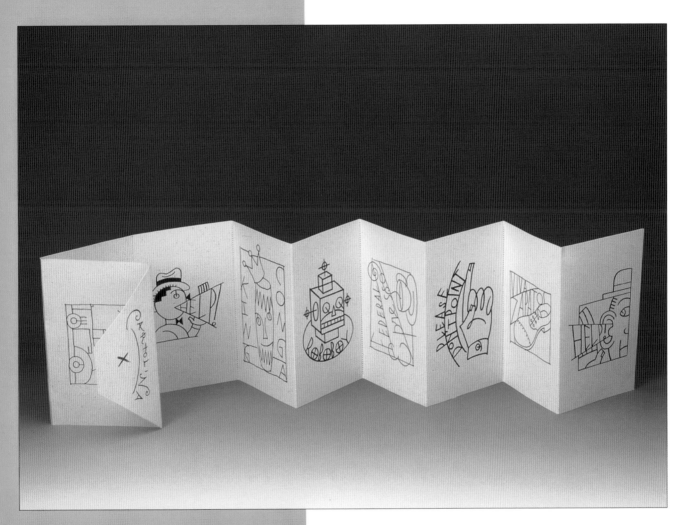

Client: **Galleria L'Affiche**
Design: **Steven Guarnaccia**
Art Director/Designer: **Steven Guarnaccia**

Seven postcards compose this accordion-fold
collection inviting recipients to an exhibition of work
by Steven Guarnaccia entitled "Ricordo di Guarnaccia"
at the Galleria L'Affiche in Milan, Italy. The piece is
one in an ongoing series of announcements that seeks
to entice recipients to come see the illustrator's work.

Build a Relationship

Client: **Pentagram**
Design: **Pentagram**
Partner/Designer: **John McConnell**

The venerable design firm Pentagram has created a wonderful collection of booklets that offer a unique outlet for the partners' creativity. Pentagram publications help educate clients about visual and creative thinking while persuading them to consider their services. The Holiday booklets like "Six Tunes for Eight Wine Bottles," package fun, amusement, and a keepsake into a small printed piece that becomes a collectible. Over time, clients have come to anticipate receiving these booklets in the mail.

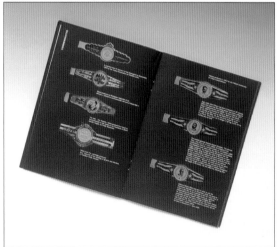

Client: **Pentagram**
Design: **Pentagram**
Partner/Designer: **John McConnell**

Pentagram has done a brilliant job of designing small "relationship building" booklets that are part of a series called Pentagram Papers. The Papers focus on "curious, entertaining, stimulating, provocative, and occasionally controversial points of view" of interest to the partners. The booklets are all printed on the same heavy black matte stock to give consistency to the pieces year after year.

Client: **Pentagram**
Design: **Pentagram**
Partner/Designer: **Michael Gericke**

"How good is your taste?" challenges clients on their aesthetic acumen by posing a series of questions that tests design fundamentals, such as proportion, pattern, scale, and even haircuts. The answers at the back reinforce the notion that Pentagram has the best solution for meeting clients' needs.

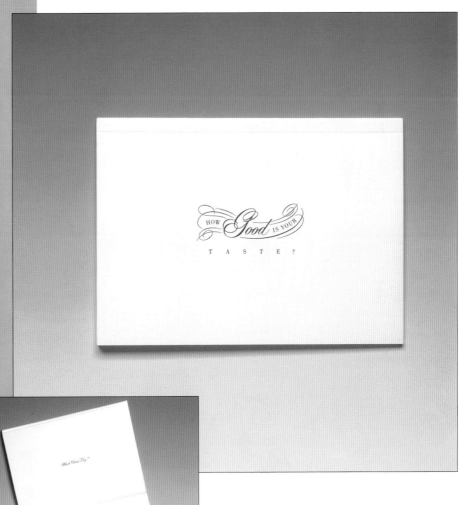

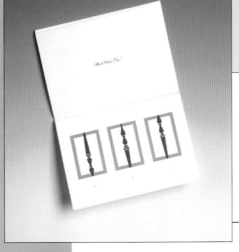

Reactive Marketing

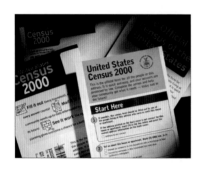 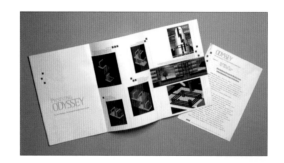 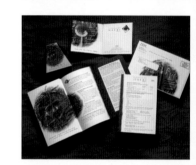

*The ability to understand and affect consumer behavior has
dimensions to it that rely on creativity but go beyond the purely
aesthetic; it is the reflection of a deep understanding of the
needs and values of a target audience and the ability to
stimulate them in ways that achieve a desired end. Whether the
means are simple or complex, the direct marketer must
react to specific information about the customer to arrive at
an effective creative solution.*

Section 2

Essay

The traditional direct marketing practice of identifying and speaking to segmented groups of customers, *even to* hyper- *or* micro-segmented *groups,* *is rapidly being replaced by a new paradigm—the creation and delivery of highly relevant customized offers designed to meet an individual customer's needs. Advances in digital technology have enabled this potential to become a reality, even an expectation. Graphic designers and direct marketers who incorporate the depth and nuance of these fundamental shifts into the programs they create can count themselves among a new generation of one-to-one marketers. In the one-to-one future, innovative designers will create efficient, flexible, highly customized designs that, as Don Peppers and Martha Rogers, Ph.D. explain, will require a radically new way of communicating messages that are relevant and meaningful to individual recipients—a new way of visualizing whatever business you are in.*

LHS and DJK

CAN WE TALK?

by Don Peppers and Martha Rogers, Ph.D.

Today we are passing through a technological discontinuity of epic proportions, and most of us are not even remotely prepared. Current developments in communications and information technologies will radically change the relationship between business and customers. Communications and information technologies now on the near horizon will totally eliminate the underlying basis for mass marketing itself. New rules, new tactics, and entirely different competitive strategies will have to be devised. As unwelcome as it may seem, the "mass" in mass media is beginning to erode.

An entirely new frame of reference—a new paradigm—for marketing is emerging. It is a paradigm based not on mass markets, but on markets of one customer at a time. This paradigm did not spring from the imperatives of assembly-line manufacturing, but from the possibility of computer-controlled, customized production, individualized distribution, and addressable, interactive commercial media. This new marketing paradigm is totally distinct from mass marketing. It will not be an evolutionary change but a revolutionary one. It will shift the entire frame of reference of business competition. The goal is to develop a radically different way of thinking about business—a new way of visualizing the fundamental basis of competition in whatever industry you're in. The central idea is that to be able to compete effectively by using 1 to 1 technologies, you will first have

to change completely the way you think about and approach the very act of competition itself. Information technology and interactivity are redefining the very essence of what it means to do business.

To work successfully in a 1 to 1 world, you will have to calculate your success one customer at a time. You will need to focus your efforts on share of customer, not market share. There is a difference between seeking a greater market share, and seeking a greater share of customer, one customer at a time. Trying to increase your market share means selling as much of your product as you can to as many customers as you can. Driving for share of customer, on the other hand, means keeping customers longer and growing them bigger.

To compete in the Interactive Age we have to be able to treat individual customers differently, and that means understanding customer differences. The value of a customer determines how much time and investment should be allocated to that customer, and a customer's needs represent the key to keeping and growing that customer.

The key share-of-customer requirement is to know your customers individually. You must know which consumers will never purchase your product at all, so you can stop

spending money and effort trying to get them to do something they never will. And you must know who your loyal customers are, so you can take steps to lock in any of their future business. Instead of *reaching* your *target* audience, think of having a *conversation* with these *individuals*. But just how do you conduct individual conversations—dialogues—with your customers?

The word "dialogue" is one of the most overworked and misused words in today's marketing lexicography. Every management consultant, every advertising professional and marketing executive will stress the importance of creating dialogues with and getting feedback from customers. For the most part, however, they aren't really talking about dialogues. So before we can examine what a dialogue is, maybe we ought to agree on what it isn't.

Having a dialogue with your customers does not consist of doing a series of one-on-one interviews with actual customers in order to get feedback for the marketing plan. That kind of research is important, even critical, to any successful marketing effort, but it is only dialogue with the particular customers involved in the research effort—a sample.

Having a dialogue does not consist of sending out millions of pieces of mail and making a sale to 0.5 percent of the addressees. It is not dialogue if you make sales to two percent, or even ten percent, of the addressees. Most mass mailings are simply monologues in an addressable format. They are little more than broadcast soliloquies, with envelopes and stamps. Many companies do it with their current customers as well as noncustomers, but it's not dialogue.

A dialogue is an exchange of thought between two or more parties. The word comes from the Greek word for conversation, which became the Latin word *dialogus*, eventually making its way into English as "dialogue," from the French word of the same spelling. (The term is sometimes misconstrued to imply a conversation limited to two people, probably because the "dia-" prefix is easily confused with "di-.")

Conducting a dialogue with a customer is, in a sense, having an exchange of thoughts. It is a form of mental collaboration.

It may include handling a customer inquiry, as would be the case with most of the calls to the consumer hot lines at the major package goods and food companies. But it should not be limited to that.

It could mean gathering background information on the customer. But it should not be limited to that.

Most customers are not going to be jumping for joy at the prospect of conversing with you. We customers have too many other things to do, and we are increasingly cynical. Seventy percent of us are too young to remember life before television commercials. We are not nearly as trusting

of marketers as we once were, nor are we as patient, nor do we have the time to investigate every product or brand. For the most part, we are even somewhat hostile to marketers, having lived through decades of progressively more adversarial mass marketing.

At one time, on the top of the form used by the advertising agency Chiat/Day for writing its creative briefs, the agency's executive creative director, Lee Clow, had printed these words: "The audience doesn't like you, doesn't trust you, and they can get rid of you immediately. Now go create some advertising."

This sentiment precisely captures the essence of today's adversarial relationship between most customers and most marketers. They don't really like each other. Customers put up with the sales messages, advertising, and semi-believable hype put out by the marketers, but they don't have to like it, and for the most part they don't.

Against this background, how does a marketer have a simple conversation with an individual customer? A genuine conversation is, after all, a consensual act.

In fact, there are four criteria that any marketing communication must meet before it can be considered to be dialogue with individual customers.

1. *All parties to a dialogue must be able to participate in it.* Each party must have the means to communicate with the other. Since mass media are non-addressable, they cannot, by definition, create dialogue.

2. *All parties to a dialogue must want to participate in it.* In most cases, this means that the subject of a 1 to 1 dialogue must be of interest to both you, as a marketer, and to your customer.

If a customer wants to talk at all, it will probably be about how to take less time to make complex decisions, how to evaluate a variety of products or brands quickly, how to have more fun, look better, make more money, or live longer. To the extent you can play a credible role in that kind of discussion, you can deepen your relationship with that particular customer.

Another way to engage your customer willingly in a conversation is to compensate him for it explicitly, either with money, or with merchandise or service. This is an expensive option, but one that frequently can come in handy.

3. *Dialogues can be controlled by anyone in the exchange.* Monologues are totally controlled by one party—the speaker. Mass-media monologues are controlled by the marketer. Anyone within earshot of a monologue will hear it, although not everyone will want to.

4. *Your dialogue with an individual customer will change your behavior toward that single individual, and change that individual's behavior toward*

you. As human beings converse and collaborate, their attitudes, actions, and future thoughts are affected. You can only be engaging in a genuine dialogue with an individual customer if you alter your future course of action in some way as a result of the exchange. For the same reason, the customer will also react to a dialogue.

In the face of rising consumer cynicism, time pressure, and impatience, a dialogue marketer will remain a dependable collaborator with his customers. Instead of the sales-oriented commercials and advertisements that characterize much of today's mass-media barrage, tomorrow's successful share-of-customer marketer will be inviting a consumer to begin and sustain a dialogue.

If you think about it, this is not unlike the implicit bargain that underlies most mass media today. "Watch my commercials and I'll bring you the television program for free. Read my ads and I'll help pay for the cost of producing the magazine or newspaper."

But for the dialogue marketer—the 1 to 1 marketer—the bargain will be an increasingly explicit bargain, made with one customer at a time. The new dynamic creates a "customer feedback loop" with each individual customer. The customer and business together redefine what it means to participate in a commercial relationship.

I know you. You tell me what you want. I make it. I remember next time. What could be simpler?

Simple to understand perhaps, but not to implement. Adopting the 1 to 1 model is not so straightforward as identifying an additional niche market, for now the marketing process itself can no longer be confined to the sales and marketing departments or the ad agency.

The reward for becoming a 1 to 1 enterprises is immense. In terms of continuing business, the *1 to 1 enterprise can make itself practically invulnerable to competition from other firms—even from other 1 to 1 enterprises, offering not just the same products, but the same level of customization and relationship-building.* At this point, before any customer can get equivalent level of service from a competitor—even one that offers the same level of interaction and customization—the customer must teach this new firm what he has already taught the original one. Over time, the one-to-one enterprise not only makes the customer more and more brand loyal, it increases its own value to that customer—as every interaction leads to a better-tailored service or product.

It all begins with dialogue and the explicit bargain, "I'm bringing you something of value, some information or entertainment that you want, and in return I want to hear from you. Tell me about yourself."

Adapted for *Design for Response* from the international best-seller *The One to One Future: Building Relationships One Customer at a Time* (Currency/Doubleday, 1993), by Don Peppers and Martha Rogers, Ph. D. and from *Enterprise One to One: Tools for Competing in the Interactive Age* (Currency/Doubleday, 1997) also by Peppers and Rogers.

Don Peppers and Martha Rogers are partners at *Marketing 1 to 1/Peppers and Rogers Group,* a forty-person management consulting firm in Stamford, Connecticut, specializing in interactivity, marketing technology, relationship management, and business development.

Chapter 3

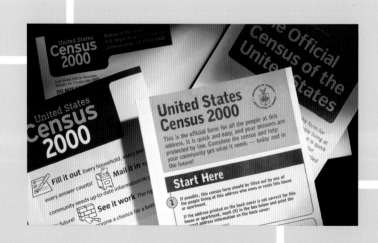

Tell Us About Yourself

Forms intended to gather information are the ultimate graphic listening devices. *Question marks, blanks, and fill-in spaces are their visual terrain. The best are also superb communicators, active practitioners of all the verbal and nonverbal cues that send a message. They take an open, inviting posture toward the person sharing what is often closely guarded information. They seem to lean forward, carefully selecting copy lines that reassure the reader that this is a safe place to divulge information, an increasingly formidable challenge when the intent is to capture the highly personal tastes and desires of a person—all the raw data of value to anyone, anywhere. Savvy information-gathering forms create a friendly, inviting atmosphere for participants. Lastly, such forms are direct, maintaining eye contact by presenting information in a clear, organized, intelligent way. They subtly communicate sensitivity to the emotional barriers associated with filling out forms, building trust through dialogue and feedback. The process, therefore, is as much about managing content as tapping creativity in the quest for a uniquely personalized exchange.*

A DESIGN YOU CAN COUNT ON: CENSUS 2000

THE DESIGN TEAM

CLIENT — **THE U. S. CENSUS BUREAU**

DESIGN — **212 ASSOCIATES**

Principal — **JULIE MARABLE**

Designers — **JULIE MARABLE**

SYLVIA HARRIS WOODARD

"It all started when Dr. Martha Farnsworth Riche, Director of the Bureau of the United States Census, had to go to Capitol Hill to get her funding appropriated. During those meetings, Congressman Harold Rogers from Kentucky expressed strong feelings that the U.S. Census form didn't work and requested that Dr. Riche redesign it so that people would *want* to fill it out," recalls Julie Marable, principal of the New York-based graphic design firm 212 Associates, about the initial events that led to an unprecedented strategic and creative challenge: how to design a form that would generate a 100 percent response rate for the largest mailing in the history of the Bureau, the Census 2000. Marable and Sylvia Harris Woodard, a Yale professor and former 212 partner, were awarded the project based on extensive involvement in public information design. "They could have hired any number of companies to do forms, but they wanted to rethink the entire process and we gave them a good case for that in our proposal," Woodard explains. Thus, an extraordinary collaboration began that will end in

late 1998. By then Marable will have devoted four years to a single client on a single project that will affect the lives of millions.

As the preeminent collector and provider of data about the people of the United States, the Bureau aspires to count every living person in the country—old and young, citizen and non-citizen, apartment dwellers, homeowners, and the homeless. The results provide the government with vital information about how society is changing, information that influences decisions from national disaster compensation to where playgrounds are built. Since information reconstruction is costly, the goal is to get as high a response as possible from the mail-out form. Although the Bureau was highly motivated toward improving the old form, it took them a while to fully grasp the implications of a redesign. "It was an obvious flaw," Woodard recounts. "They were producing an information product with no information designers."

The previous 1990 decennial mailing had been done with static, machine-compatible

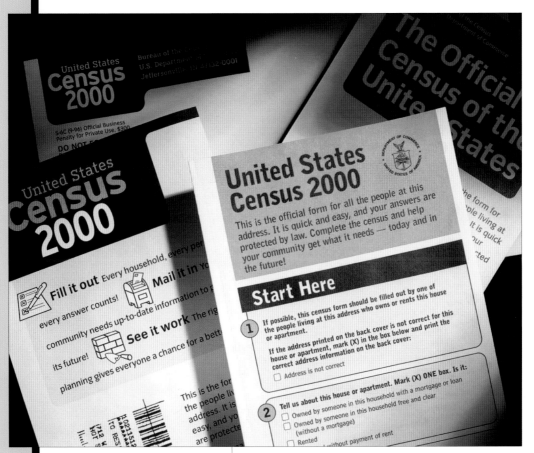

Different cover designs are tested for response rates. The results influence subsequent redesigns, often leading to a final solution that is a hybrid of the best elements from several prototypes. Yellow, instead of a darker color, helps with legibility and data capture, two important objectives for the new form design.

matrix forms composed of fill-in spaces so that scanners could easily read the data. "People were confused by the forms. They were not user-friendly. The higher the confusion, the lower the response rate," Woodard explains. As a result, many were only partially completed, or not at all. "Our [initial] purpose was to offer ideas and prototype solutions. However, the Bureau quickly reigned us in on the required production specifications." Early solutions explored how to make the forms easier to use and navigate through, bearing in mind that the census had to be processed and meet data capture requirements. It also had to look official, yet still motivate people to participate. The approved design incorporates familiar shapes and curves to soften the impact of 24

pages of questions. Tabbing breaks the information down into manageable sections and keeps the eye moving. Rounded corners on the fill-in boxes are a distinct shift away from the rigid 1990 version. Fluid lines soften the psychological barriers to completing the form in hopes that the respondent will perceive this as a safe place to divulge information, even though a response is clearly required by law. Marable also considered how the form would look in the year 2000, and made conscious choices to keep the design fresh and contemporary. "We wanted something technical, but still friendly." She chose Interstate, a highly legible yet atypical typeface designed by Tobias Frere-Jones based on highway signage, and selected an upbeat

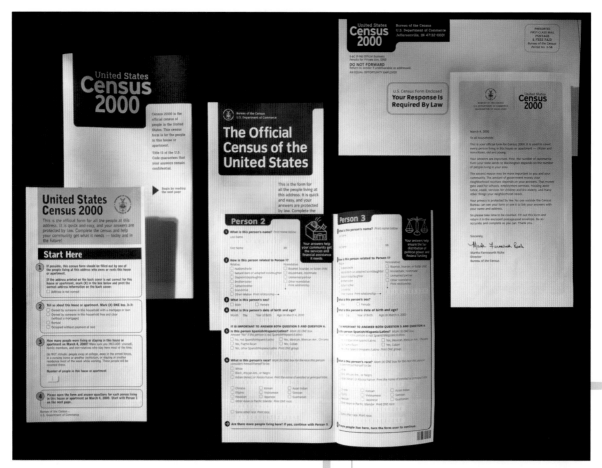

The full-scale direct mail campaign will consist of two forms, a "simple" form and a "sample" form, which are intended to capture 100 percent of citizens and non-citizens. Work on the forms began in early 1995 and continued with testing and redesign until late 1998, an unusual amount of time for any graphic designer or direct marketer to work on the same project for the same client.

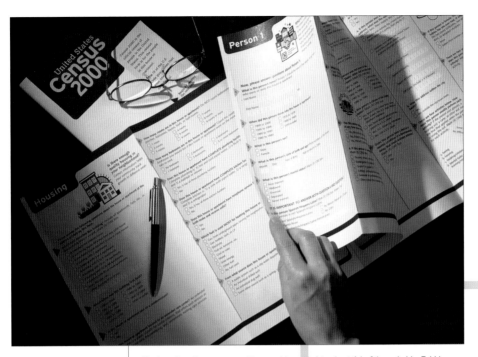

The long form has more questions and is mailed to about 1 in 6 households. Tabbing and gentle curving lines soften the overall impression, making it look familiar and friendly. Getting it that way, however, required months of analysis, testing, and redesign.

yellow background that offers good contrast to facilitate data capture. Small icons representing days of testing for the right balance of interest and inclusion begin each new category of questions. "You cannot imagine what has gone into designing icons that are simple enough for people to understand, yet not so simple that they feel insulted by them," Marable explains.

To build a trusting dialogue between the Bureau and the recipient, information-gathering tactics embrace three critical messages: the direct benefit to the recipient for participating, the protection of individual privacy, and an explanation of how the information will be used. Throughout, the tone of the copy is informed and reassuring. An interrogative voice and an explanatory voice guide the participant through the form so that anticipated barriers to answering a question are acknowledged and addressed. Headlines like, "Your answers help your community provide services for people of all ages," and "Knowing about age, race, and sex helps your community better meet the needs of everyone" reinforce the personal benefits of fully completing the form.

To reassure the participant that his or her privacy will not be violated, bold statements like, "Nobody outside the Census Bureau can see your form or use it to link your answers with your name and address," and "The confidentiality of your answers is protected by Title 13 of the United States Code" stand out in contrast to the questions. Lastly, the use and relevancy of the information are fully explained in statements such as, "Include your phone number in case we need to call you if we don't understand an answer," and, "Why do you need to know how old I am? Depending on your answer, your community may need to plan for more schools or more eldercare facilities."

The forms are still in the testing phase, a balancing act that involves holding on to the freshness and integrity of the design while incorporating feedback and numerous requests for changes. "We have been pushing them to test everything that we design," emphasizes Marable. "As a designer, there are decisions you think are obvious. But, when placed in front of the user, you discover people get confused or hung up on the content or the graphics. It's very

Information-gathering tactics include three critical building blocks: an assurance of privacy, an explanation of how the information acquired will be used, and a direct benefit to the recipient for providing the information.

Since scanners are often used to pick up answers, pale background colors offer a good contrast that ensures accuracy and provides legibility even with black ink printed over them, an important consideration for people with impaired vision.

Curved lines and shapes have a fluid, receiving effect that softens the psychological barriers to filling out a form, reinforcing that this is a safe place to divulge information.

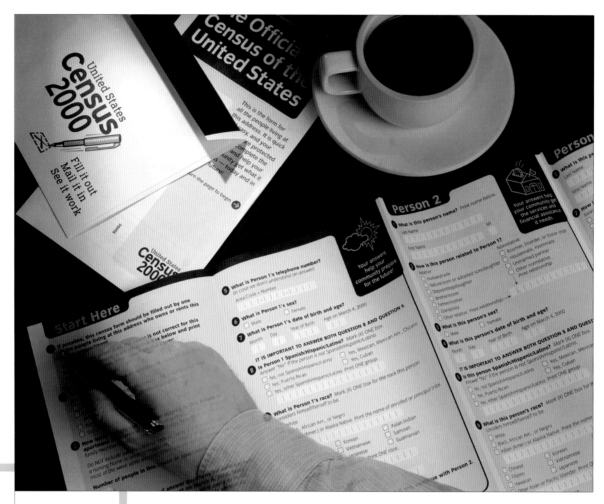

Benefit icons and statements that explain why the information
is important and how it will be used are reinforced throughout
the 24-page form. The envelope, a place people are vulnerable
to messages, clearly announces the action required: fill it out,
mail it in, see it work.

revealing. You can never design something too simply. The results of cognitive, focus, and mail-out tests guide us in what to do next. We just keep redesigning, all in an effort to make the forms more friendly and inviting and to have a high response rate in 2000."

The new forms seek to synthesize images and language that are ageless, genderless, and raceless yet still resonate with meaning. "You have to come up with statements and pictures that will appeal to everyone living in this country. It is almost an impossible task," Marable says good-naturedly. To represent the vast complexity of races, languages, and predilections across America through distinct

yet familiar images and words elevates the Census 2000 mailing from mere information gathering to cultural ambassador for the federal government, inviting every person in the United States to participate in the chance to meet the needs of society as it enters a new millennium.

 Housing

Housing information helps your community plan for police and fire protection.

 Person 1

Your answers are important! Every person in the census counts.

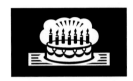 Person 2

Your answers help your community provide services for people of all ages.

 Person 3

Census information helps your community get financial assistance for roads, hospitals, schools, and more.

 Person 4

Information about children helps your community plan for child care, education and recreation.

 Person 5

Knowing about age, race, and sex helps your community better meet the needs of everyone.

 Roster
(short form only)

Your answers help your community plan for the future.

Ageless, genderless, and raceless images define a graphic style that might be called "American melting pot." Statements and icons become visual metaphors that communicate the benefits of filling out and returning the form, an important involvement tactic when the audience is so vast and so many different languages must be accommodated.

Tell Us About Yourself

gallery

Client: **Learjet**
Design: **Greteman Group**
Art Directors/Designers: **Sonia Greteman, James Strange**
Illustrator: **James Strange**

For a survey to gauge jet owners' satisfaction with quality and performance, Learjet offered this small, graceful booklet. Carefully crafted to suit an exclusive market, the appealing response card balances the straightforward approach of a pilot's checklist with subtle graphics that suggest glamour and exploration. Offset printing on passport paper enhances the overall richness and quality of the booklet.

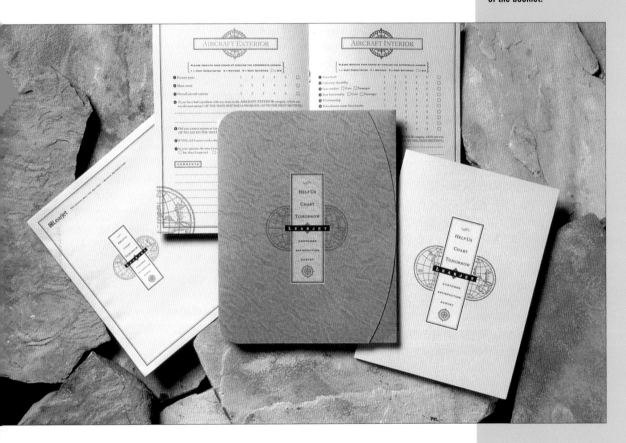

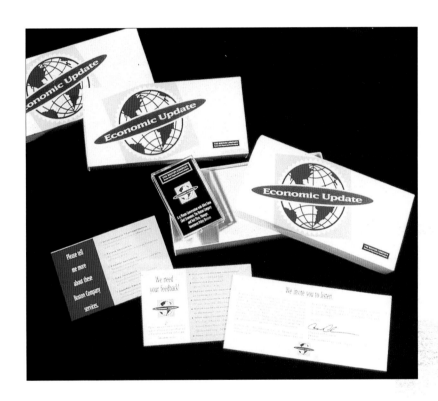

Client: **The Boston Company**
Design: **Selbert Perkins Design**
Designer: **Mary Lewis Chiodo**
Illustrator: **James Krause**

The Boston Company's direct mail insert reads, "We invite you to listen." Cheerful graphics on the box lid tell the story; inside, an audiotape features experts speaking on global topics and providing recommendations for making the most of economic opportunities.

Tell Us About Yourself

Client: **Geron**
Design: **Cahan & Associates**
Art Director: **Bill Cahan**
Designer: **Bob Dinetz**
Editor: **Carole Melis**

When the Geron Annual Report is mailed to potential stockholders, it is paired with a small book titled *What Does Getting Old Mean to You?* Inside, an array of portraits accompany answers to this question. At the back, a postage-paid return post card asks readers to contribute their views on what it means to get old. Geron collects these responses for use in the next year's report. The publication of this little book has been amazingly helpful in terms of appeal and name recognition—hundreds of response postcards now decorate the company's hallways.

WHAT DOES GETTING OLD MEAN TO YOU?

When you bend down
you don't get up as fast.

Take one day
at a time sweetie.

I DON'T FIND GETTING
OLDER INTIMIDATING.
I CAN STILL DO THE SAME
THINGS I'VE ALWAYS BEEN
ABLE TO DO... I JUST
CAN'T DO THEM
AS FAST.

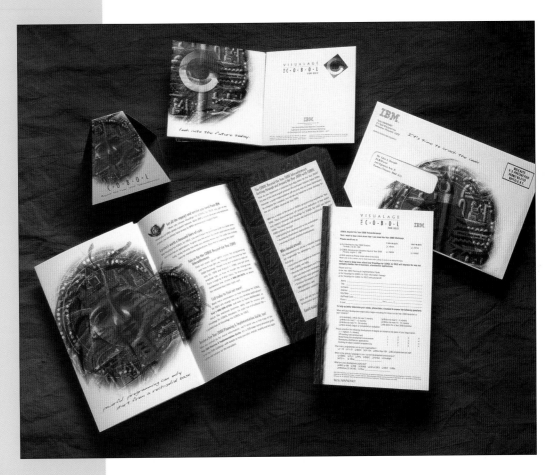

Client: **IBM (Cobol-Visual Age)**
Design: **The Riordan Design Group, Inc.**
Art Director: **Claude Dumoulin (FCB Toronto)**
Designer: **Dan Wheaton**
Illustrator: **Dan Wheaton**

Dramatic, four-color printing, the visual metaphor of Egyptian hieroglyphs, and a "Crack the Code" tag line prove almost irresistible to the curious. To market IBM's Cobol computer product for the "turn of the century bug," this mailer is immediately engaging and unfolds to solicit the reader's response. Marketing against type, the design's handwritten statements, playful color, and a decidedly "non-computer" sensibility humanize the package for maximum response.

Chapter

Come for a Visit, Give Us a Try

Trial is a response that will usually not be evoked immediately. *Recipients of offers designed to elicit a visit to a car dealership or to try a new toothpaste are unlikely after reading an offer to hop in their cars and head straight for the nearest retailer. However, it is our premise that all successful direct marketing must generate an immediate tangible response. Any delay will decrease the response rate. Reader involvement tactics begin an immediate relationship with the piece, and thereby with the offer. In direct marketing, as in life, it is far more difficult to walk away from something, or someone, with whom you have a relationship.*

Credibility, creativity, and connective narrative content yield persuasion. *Here, a "micro" direct marketing agency, Decker, recreates architectural history to ensure the life of an elevator forty years in the making.*

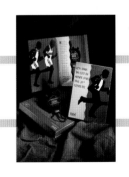

THE WRIGHT STUFF: OTIS ELEVATOR

THE DESIGN TEAM

CLIENT — **OTIS ELEVATOR**

DESIGN — **DECKER**

Client Contact — **PETER KOWALCHUK,**
Director,
International Communications

Strategic Director — **ANDREW MAGUIRE,**
Executive Vice President

Creative Director and Copy — **JAY DUREPO,**
Executive Vice President

Senior Art Director — **GLORIA PRIAM**

Imagine for a moment you are a famous architect. Philip Johnson, say, or I.M. Pei. You receive via Airborne Express a plastic bag from the Bureau of Damaged and Delayed Mail along with an apology note explaining that the enclosed article was misdirected in handling. You flip over the contents and glance at the return address: Taliesin, Spring Green, Wisconsin. Legendary home and studio of Frank Lloyd Wright. You glance, in disbelief, at the postmark stamped 1956. You marvel at the finely engraved three-cent stamp and are swept up in modernist visions of the past. In this case, a past filled with waterfalls and hollyhocks, cityscapes and futurist dreams, joyous expressions of American architecture. A letter lost for forty years, from the master himself? Wright resurrected? The creamy envelope is slashed with dirty scuff marks, as if it had been tossed among forgotten mail sacks for years. You open the envelope, remove the letter and read Taliesin in small, precisely spaced orange letters. The sans serif graphics carry you back to Wright's long, low structures, deep eaves, and horizontal rhythms reaching out to the prairies. You unfold the letter and begin reading, "My dear. . . ." Your eyes scan to the signature: "Faithfully yours, Frank Lloyd Wright." What on earth is this?

The complicitous voice of Wright rises out of the broken typewriter letters, casting aspersions on those unable to keep pace with his vision for a Mile-High building. The Mile-High building, he explains, is key to the future of urban living, a peaceful, plentiful, secure place "where nature surrounds and permeates." The only impediment to its creation is "a practical system to move occupants into and throughout." You read on to discover that the letter is a time capsule announcing that Otis, inventor of the elevator, will at last unveil an "integrated building transit system," the missing link to the Mile High, on July 25, 1996. You are baffled and mesmerized.

You read through the letter a second time, and thus begins the process by which Decker, "America's premier MicroAgency" based in Glastonbury, Connecticut, uses an ingenious

TALIESIN

My dear Mr. Schneider:

As you doubtless know, I have unveiled my Mile-High building, The Architect and the everyman have passed their judgments, many critical, some skeptical.

Such ignorance. Derisive comments could come only from those insensitive to the survival of our cities. If urban living has a future, it is in peaceful, plentiful, secure environments like the Mile-High. Places where nature surrounds and permeates.

The structure is entirely feasible. The materials are available now, as are the engineering technologies. We wait only for a practical system to move occupants into and throughout. It has come to my attention that Otis, inventor of the elevator, has embarked on an odyssey to develop an integrated building transit system. I understand that they will unveil it on July 25, 1996.

Regrettably, my schedule does not permit me to participate. But I remain,

Faithfully yours,

Frank Lloyd Wright

September 14, 1956

SPRING GREEN W
PM
14 SEPT
1956

TO: Mr. Irwin H. Schneider
 Szaka & Hennessy - NY
 52 Robinson Road
 #20-01 City House
 #0106
 Singapore

Among the pinnacles of American architecture is the work produced by Frank Lloyd Wright, a visionary who challenged his peers to create innovative structures far beyond the technical capabilities of their time. His grand schemes never lost their appeal, a fact turned to unique advantage by Decker Communications for a direct mail campaign to launch "Odyssey," an integrated building transport system manufactured by The Otis Elevator Company. Wright's legacy endures in the form of a personalized letter "lost" in the mail since 1956.

direct mail campaign to reposition Otis Elevator as the leader in the category and generate qualified sales leads for the company's new, not yet fully prototyped, "integrated building transit system" called Odyssey. Otis had never used direct marketing as a key element in a product launch before. The point of entry for how to execute a globally coordinated event to mark the launch of Odyssey came through rigorous, thoughtful consideration of the target audience: the leading architects of the world. Decker knew something of deep relevance to them would be required to succeed. The resulting program managed to push past the inevitable gatekeepers, generate a sixty-percent response rate from a $350,000 campaign budget, and win the 1997 Platinum Echo Award from the International Direct Marketing Association. They also generated over two billion dollars in qualified sales leads.

Otis was impressed.

The real beginning, however, was forty years earlier when the Illinois, a mile-high building that began as an assignment to design the world's tallest broadcast antenna, was born. "Sheathed in aluminum and stainless steel, the Illinois was a dramatic, tetrahedral sword. It was poised to slash at the indifference of the Bauhaus box, rustic ideas of building construction, and timebound concepts of urban life," reads the sales brochure, the second critical element of the campaign following the lost letter announcement of the coming of Odyssey. "The only barrier between vision and reality was a suitable transportation system." Otis leverages Wright's vision to a virtual product for today's architectural giants, inspiring them to participate in the realization of his master plan through the purchase of an intrabuilding "circulatory" system.

By resurrecting the name of Frank Lloyd Wright, the launch is given authority and cachet. To entice architectural pioneers of the twentieth century to realize the master's vision, a sales brochure including a CD-ROM quickly follows the lost letter explaining, in a way that continues the narrative, the performance benefits of this innovative "circulatory" elevator design.

In a word, Odyssey is extraordinary. The elevator, the "upended street," has been turned on its side. As the world's first solution to transportation into, within, and between vertical and horizontal buildings, it is truly an Integrated Building Transit System. The product announcement binder and brochure that followed the letter included a CD-ROM, press releases, and a reproduced poster of the mile-high skyscraper. The deep jewel tones of the binder and brochure speak to the tastes of an essentially conservative clientele. Beautiful, dramatic renderings of a modernist skyline and Wright's futurist visions by architect and architectural artist Thomas W. Schaller set the stage for an in-depth look at Odyssey. A buff outer envelope introduces the product with the printed line "Odyssey. It's time for a new paradigm."

For such a discriminating audience the letter had to be highly convincing. To guarantee authenticity they reproduced Frank Lloyd Wright's typewriter face and signature, and mimicked his writing style and vocabulary. Dirt, grass, and shoe polish were used to help achieve the aged effect needed. Decker searched New York for 2,000 genuine three-cent stamps and then postmarked them "Spring Green, Wisconsin 1956." Phase Two of the ambitious scheme involved the simultaneous global mailing of the launch brochures via Airborne Express to coincide with the anticipated media announcements.

To further engage the audience, Decker personalized the postscript of several individual letters in ways that recall personal anecdotes or memorable exchanges with Wright. Philip Johnson had been quoted on his ninetieth birthday as saying that he was "not in the same league as Frank Lloyd Wright." Johnson's letter alluded to the remark with a 1956 paragraph from Mr. Wright thanking him for "the kind words you will say about me on your ninetieth birthday." Similarly, early in his career I. M. Pei was so frightened by Wright's dogs when he visited Taliesin that he left before he could meet his hero. In the letter to Mr. Pei, Wright apologized for the behavior of his dogs.

The creative weave of relevance, credibility, one-to-one marketing tactics, and top-notch coordination makes the Odyssey launch special. The challenging part was to make out of the events of the past and the tools of the future an event of importance today that tangibly motivates architects and contractors to seek out Otis's unique technology. The power of Wright's rebirth, and hence Odyssey's launch, is founded on an attachment to a dream for improving the beauty, complexity, and efficiency of the world's skyscrapers, an exhilarating trigger for feeling part of something larger and more meaningful.

The Odyssey campaign is a unique blend of emtional and rational reasons for giving serious thought to a truly advanced product. By dispensing information in carefully measured "bites," each piece of communication builds on the previous one, guiding consumers through the persuasion process until they no longer ask "why" but rather "why not?"

Direct marketing is most effective when it is part of an integrated communications plan that speaks directly to the individual needs of the customer. The message, therefore, must be as relevant as the product or the service. It should clearly communicate a well-defined strategic advantage. Competitive strengths to emphasize include price, quality, performance, innovation, brand name, featured benefits, reliability, and image.

Come for a Visit, Give Us a Try

Client: **The Corbis Corporation**
Design: **Hornall Anderson Design Works, Inc.**
Art Director: **Jack Anderson**
Designers: **Jack Anderson, John Anicker, Margaret Long, Mary Hermes, Jana Wilson**
Photography: **Corbis Archive**

The Corbis digital collection features more than 700,000 images from premier photographers, museums, and private archives around the world. With the dual goals of driving traffic to its online catalog while educating customers about how to order, Corbis's color-rich print catalog highlights small samples of images and features the web site URL on the cover. Leads were generated from the response cards included. Ample white space, vellum end papers, and discrete gold type give this elegant piece an added dimension of quality.

Client: **Crane Business Paper**
Design: **Design: M/W**
Art Directors: **Allison Muench Williams, J. Phillips Williams**
Designer: **Peter Phong**

With its fresh spring-like colors, whimsical line drawings, and miniature envelope created expressly for business cards, the format for this series of invitations to nationwide events hosted by Crane Business Paper offers a direct experience with its stationery products and the added value of a tactile feature.

Client: **GE Capital Assurance**
Design: **Hornall Anderson Design Works, Inc.**
Art Director: **Jack Anderson**
Designers: **Jack Anderson, Lisa Cerveny, Susan Haddon**

This boldly colored financial services kit was designed to market GE Capital Assurance's capabilities. What is singular about the kit is the way it transforms an often dry, intimidating subject into a simple-to-understand, easy-to-follow, stimulating read. A chartreuse, pumpkin, and black palette is enhanced by bold, sans serif type to give a weighty topic an uplifting boost of energy for both agent and consumer.

Client: **Takashimaya**
Design: **Design: M/W**
Art Directors: **Allison Muench Williams, J. Phillips Williams**
Illustrator: **Anders Wenngren**

Building multiple features into a unified self-mailer is one of the greatest challenges for a direct mail designer because it requires a lot of strategy in a small area. The innovative East/West department store Takashimaya mailed "Spring Things," a set of perforated postcards and event announcements, to invite select shoppers to enjoy accessories artisans' presentations of their work. (The illustrations offer a different form of communication than Takashimaya's catalogs, which regularly emphasize photography.) The postcards invitingly whisper "Join other people; Mail this to a friend; Make it a shared experience."

Client: **[T-26] Digital Type Foundry**
Design: **Segura Inc.**
Art Director: **Carlos Segura**
Designers: **Assorted**

Swirling surfaces cover this collection of quick-time movies about type. Soft paper packaging secured by two metal nuts and bolts contrast with the slick surface of the plastic jewel-case and CD. New faces are introduced through movement on the screen. "So alive it shouts," suggests the pop explosion on the label as it invites the reader to call for a catalog or order form.

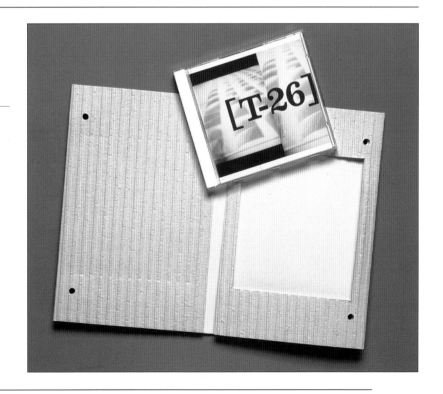

Come for a Visit, Give Us a Try

gallery

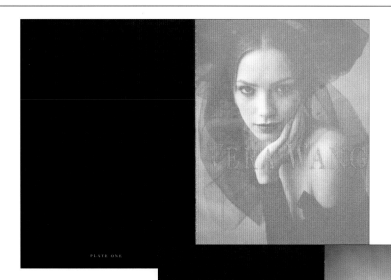

Client: **Vera Wang**
Design: **Socio X**
Art Director: **Bridget de Socio**
Designer: **Albert Lin**

This alluring brochure captures the winning combination of an upscale attitude with a relaxed pose to reassure prospective brides that they're sure to find the right one-of-a kind dress at Vera Wang. The layout intentionally evokes the impression of models parading on the catwalk to give the reader the feeling of a personal preview. Bold type, vellum paper, and photographs of sleek models in elegant gowns overlap to create depth so that the eye moves back and forth between body, dress, prop. The result is a small, black book where lush sensuality is given cinematic pacing to introduce an element of time.

Client: **Cable Services Group**
Design: **Webster Design Associates, Inc.**
Art Director: **Dave Webster**
Designers: **Dave Webster, Phil Thompson**

For the exclusive unveiling of Oasis, a software system for monitoring cable television subscribers, this invitation builds interest by building a story and casting the recipient as a character. A glass bottle, cached with care in shredded paper, holds a message worth keeping. The presentation, nicely mirroring the product name, *Oasis*, promises more good things to come.

Client: **IBM**
Design: **Webster Design Associates, Inc.**
Art Director: **Dave Webster**

A stopwatch drives home the message for this limited-time, computer upgrade promotion. Slick production values and strong design present an "act fast" urgency—from the wavy die-cut and "stop-traffic" colors to images of a corporate figure's metamorphosis—all making a pitch for speedy response.

Client: **Ron et Normand**
Design: **Moondog Studios, Inc.**
Art Director: **Odette Hidalgo**
Designer: **Derek von Essen**
Photographer: **Cindy Sommerfield**

Enticing in a sea of fashion catalogs, Ron et Normand attracts attention with breezy type (drawn by hand, then digitally re-created) and an upscale attitude with a relaxed pose. The cover gives way to black-and-white interior photos whose lack of color enhances the fluid shapes of the clothing. White backgrounds, minimal type, and evocative titles (such as *Aquarius* and *Bain de Soleil*) for the clothing, all work together to make the reader the "star" of the catalog. Each page suggests "this could be you," to reassure prospective buyers that they're sure to find the right one-of-a kind outfit at Ron et Normand.

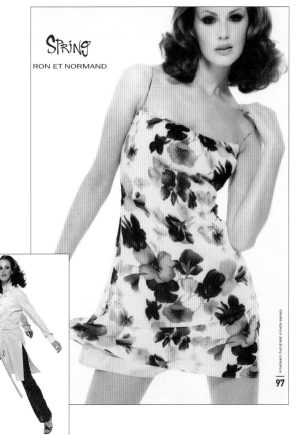

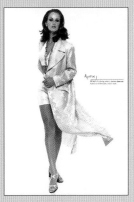
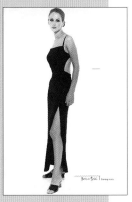

Come for a Visit, Give Us a Try

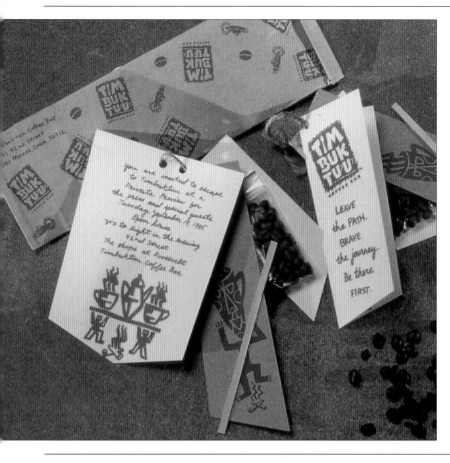

Client: **Timbuktuu Coffee Bar**
Design: **Sayles Graphic Design**
Art Directors: **John Sayles, Jennifer Elliot**
Designer/Illustrator: **John Sayles**
Copywriter: **Annie Meacham**

Created for the grand opening of Timbuktuu coffee bar, this invitation brings a café atmosphere to the recipient: stir sticks, a bag of coffee beans, and other "leftover" materials are incorporated in a rustic-looking design that mirrors the interior design of Timbuktuu. The success of this type of direct mail depends on immediate consumer appeal—crafting the invitation as a "sampling" of the physical space or service to take the audience a step closer to trying the real thing.

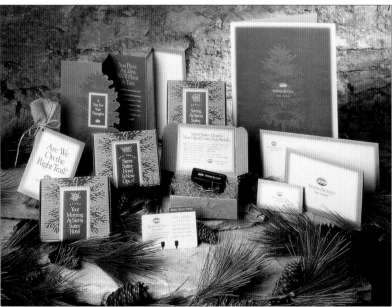

Client: **Sierra Suites**
Design: **Greteman Group**
Art Directors: **Sonia Greteman, James Strange**
Designers: **Sonia Greteman, James Strange, Craig Tomson**
Illustrators: **James Strange**

Handsomely targeted, Sierra Suites campaign focuses on the busy executive: office supplies packed in attractive boxes keep the hotel's name on top of the desk for easy access to reservations. Two-color offset printing in metallic copper and deep green lends a serene woodland feeling. The tree illustration, actually a woodcut silk-screened on the package, adds the right finishing touch.

Client: **Green Acres natural food market**
Design Firm: **Greteman Group**
Art Directors: **Sonia Greteman**
Designers: **Sonia Greteman, James Strange**
Illustrator: **Sonia Greteman**

An invitation containing nostalgic art, a fun approach, and a dash of "lifestyle appeal" generated a thirty-three percent response rate for a Green Acres open house. This natural food store wanted to combat a widely held sense that "health food" is overpriced and does not offer good value. The simple seed packet invitation, printed with a humorous headline, conveyed the company's stated mission of "honesty, simplicity, earthiness, and good humor."

Client: **Laboratoires Garnier Paris**
Design: **Giorgio Rocco**
Art Director: **Giorgio Rocco**
Designer: **Giorgio Rocco**

For this Belle Color promotion, flowing script on a simple background makes the model (and her hair color) the center of attention. All of the identity materials for this program, including the promotional brochure, were printed on a single press sheet to keep production costs low. Hand binding brings a subtle, "keepsake" element to the finished piece.

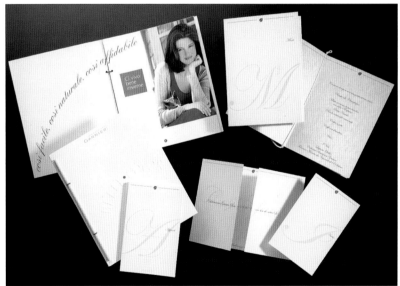

Come for a Visit, Give Us a Try

Client: **Pacific Place**
Design: **Hornall Anderson Design Works, Inc.**
Art Director: **Jack Anderson**
Designers: **Jack Anderson, Heidi Favour, David Bates**

Pacific Place, a new retail and entertainment center in the heart of downtown Seattle, draws clientele with a mailing design that expresses a bustling sense of energy and action. The mailer boasts skyscraper-size headlines and a sunburst graphic to underscore Pacific Place as a downtown destination of choice.

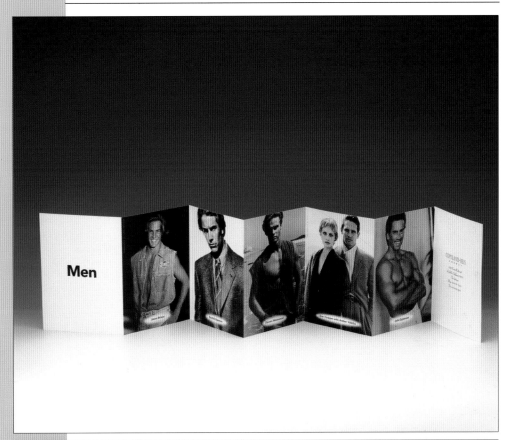

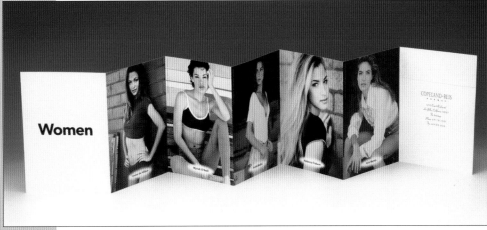

Client: **Copeland Reis Talent Agency**
Design: **Mires Design**
Art Director: **John Ball**
Designer: **John Ball, Miguel Perez**

One thousand of these coated cardstock mailers delivered a talent agency's message in clear, simple terms. Generously scaled for easy reference, the accordion-fold mailer expands to reveal an array of male and female models—the company's stock in trade. High-quality photography and production close the deal.

Interactive Marketing

 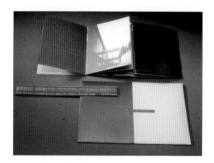

Direct marketing can sometimes seem like dancing the
tango, a slow synchronization of careful movements that lead
to a decisive response. Each customer is a potential
partner with whom the goal is not a one-time encounter but
an ongoing exchange.

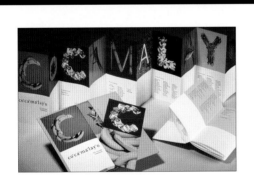

Section

3

Chapter

5

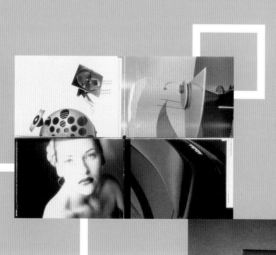

Get with the Program

**There's nothing indefinite about
the words "enroll" and "subscribe."** *They have a link in the word* scribe *and mean,
literally, to write down or record. The words imply the existence of a list, to which the inclusion of
a name was a statement about that person's needs, values, and desires, and brought with it a
communal sense of belonging.*

**Each of us has our own version
of what it means to enroll or subscribe.** *The roster of uses is long.
For the student it is school, for the soldier it is the military, for the investor it is the fund, for
the activist it is the cause. What is really needed, though, for someone to act now for something
that will be delivered over an extended period of time in the future? As Tom Patty reminds us,
the key concern is to move someone from indifference (or negativism) to greater and greater levels
of emotional and intellectual commitment. A name by itself, unless it is famous, is hard to
trade on these days, and its power to persuade has diminished. Instead, what establishes a will-
ingness to sign up is often a simple need to belong, the fulfillment of which progressive marketers
serve up glistening with all the trimmings through direct marketing campaigns that are
credible, enticing, and full of appeal.*

HEAD OF THE CLASS: ART CENTER COLLEGE OF DESIGN

THE DESIGN TEAM

CLIENT — **ART CENTER COLLEGE OF DESIGN**

DESIGN — **ART CENTER DESIGN OFFICE**

Client Contact — **STUART I. FROLICK,** Vice President/Creative Director

Design Director — **REBECA MENDEZ**

Designers — **REBECA MENDEZ**

DARIN BEAMAN

DARREN NAMAYE

CHRIS HAAGA

TARA CARSON

Photographer — **STEVEN A. HELLER**

Production — **ELLIE EISNER**

There are few incontrovertible facts about the enrollment process at Art Center College of Design. Different theories mirror the preoccupations of each department. Some consider high enrollment the final word in effectiveness, others believe the maturity and talent of the first-term class to be proof of the catalog's success, and still others suggest that anything mailed out by the school to prospective students is just a prelude to the decisive act: a visit by the student to the school.

What is known is that when Art Center College of Design in Pasadena, California, mailed out the "mustard" book, their 1993–94 recruitment catalog, it signaled a clear departure from how the school had sold itself to students at any point before. Rather than simply organizing information, the catalog sought to deliver an experience, to simulate a visit to the sycamore-shaded campus through ink on paper. Endpapers of metallic silver and Day-Glo orange, technoid lozenges for calling out type, and collaged layers of image and text were intended, says former design director Rebeca

Mendez, to "include rather than exclude, to integrate rather than reject, to suggest the world the student might enter into." The operative word here is "world." Beyond the cover you find a universe of visual and typographic codes that speak to creative, multicultural, eighteen-to twenty-three-year-old students. From a history of Bauhaus consistency, the school's communications were translated into a fractured, hybrid, deliberately nonlinear system intended to fully engage the senses, the intellect, and the spirit. This is a story of changing paradigms and these are unexpected forms of marketing savvy.

Art Center's Design Office was founded in 1986 by President David R. Brown to strategize and execute all of the college's printed materials. Stuart Frolick soon joined as vice president and creative director. In 1989 the Art Center identity was in a state of change, moving away from the rigid and predictable Helvetica of the previous two decades and toward something new. "The late 1980s was an important period because it sent Art Center in a direction of critical thinking, not at the surface but in its

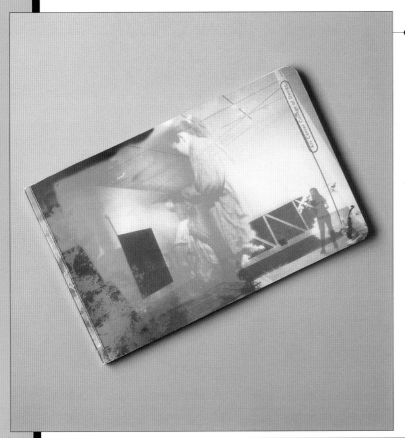

The cover design of the 1993 recruitment catalog is among the school's most evocative. Through changes in scale and transparency, Mendez transferred many of her "experiential" design ideas to a sales tool. Organic and architectural elements found on the site overlap with works of art and figures of students to allow an interplay of visual and physical, interior and exterior.

The structure of mustard yellow boxes behind black type and strong lozenge-shaped rules is combined with burned-out black-and-white photography to reinforce the nineties as a period of transition and flux. Juxtaposed images of printing presses and computer terminals illustrate the evolution of the designer's tools.

Portraits of the department chairs show the real people behind the place and generate interest in the accompanying message; a strong, inspiring statement that fuels the imagination and positions the student at the center of the learning process.

depths," Mendez explains. Her intuitive impression upon arriving was of coming to a country where you don't speak the language so that your other radars of perception are highly acute and finely tuned. From there, intuition and the senses, all the other levels at which communication is happening outside of language, became very present in the work." With Brown and Frolick's support, Mendez's overtly corporeal approach pointed the Design Office team toward a transformation of rigid notions about consistency in corporate identity, and to a more visceral expression distinct from competing schools like Cranbrook and Cal Arts.

The Design Office team envisioned a kinetic system of catalogs, announcements, posters, invitations, and brochures that spread like appendages across every department of the school. Mendez saw the identity system as analogous to the human body, with all vital facts akin to a spine, and photographs of students moving through the buildings as the equivalent of a dynamic muscular system. "It means that the place is organic," she explains. "That it is a living organism." In the same way that graphic designers visually articulate the differences between the "body" text and secondary "limbs" like footnotes, figures,

This mailer compresses visual tactics characteristic of strong direct marketing—an unusual shape, brilliant color, and elegant typography—thus showing that the basic graphic principles for generating a response are as adaptable to a simple graduation announcement as an information-rich catalog.

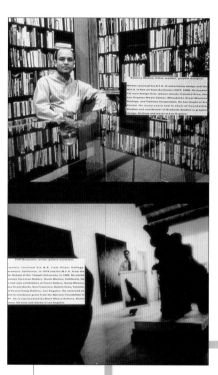

Word and pictures turn Mendez's clear-cut design into a subtle play of conflicting emotional and physical values: surrender or control, freedom or confinement, creativity or work, flesh or machine, hard or soft.

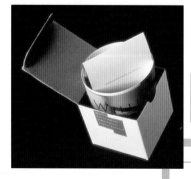

The Design Office team pushed the limits of every direct mail piece it created. By placing the long, banner-like announcement in juxtaposition to the small, compact box it is mailed in, and especially in the architecture to which it refers, the contrast between inner and outer is complete, and the appearance of both is intensified.

ENVIRONMENTAL DESIGN AT ART CENTER COLLEGE

To break from the tireless clichés commonly used to depict built form, Mendez chose a whirling dervish piece of architecture as the focal point of a poster intended to recruit environmental design students. Dynamic imagery and type become a signifier for the creative process, "hooking" students by encouraging them to visualize their own designs.

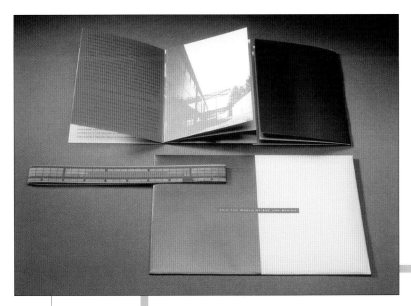

An invitation to join is a great tease to open a catalog. Here, a belly band printed with "Join the world of art and design" printed over a picture of the bridge—a signature architectural feature of the site—celebrates the school's heritage and establishes a metaphoric link between the donors to whom the catalog is targeted and the benefactors: the school and its students.

and appendices, so Mendez saw the links in information, yet considered the unique characteristics of each department and sought to provide them with stand-alone direct mail solutions.

Art Center began as the vision of Edward A. "Tink" Adams, a former advertising executive who in the 1930s identified the need for a professional design school. The school's name derived from its original location on Seventh Street in downtown Los Angeles, a district then

characterized by galleries, cafés, photography studios and thus known as the "art center" of Los Angeles. When Adams started his art school there he named it the "Art Center School." His presence endures in the color orange inspired by classic Japanese lacquerware, of which Adams was particularly fond. The highly individual architecture of the school is the work and legacy of Don Kubly, Art Center's second president. Craig Ellwood Associate's long, low modernist architecture is among the pillars upon which the school's distinct identity was

Content is one of the most significant factors in persuading a recipient to enroll or subscribe. While the message should consist of the most convincing evidence, how that information is positioned and packaged makes the difference between a mailer that is fresh and inspiring—or one that is immediately discarded.

Credibility is one of the most carefully scrutinized and elusive attributes of any direct marketing program. While it is important to leverage strengths, speaking in a visual and written language of relevance to the customer is an equally convincing strategy.

built and evolved. During the 1960s and 1970s, Kubly submitted the identity's layout and type to ever more rigorous Bauhaus ideals. Although he always changed the color of the covers of the recruitment catalogs, his exclusive use of Helvetica and an indomitable square format produced a highly recognizable image that remained until 1984 when the name of the college was left off completely, the assumption being that the presence of a 9" by 9" (23 cm by 23 cm) book of black-and-white photographs and gridded Helvetica Light were enough to communicate the Art Center catalog. A year later, David R. Brown arrived as the college's third president.

ArtCenter

Among Mendez's first suggestions as designer for the college was to reintroduce the dot to the corporate identity by placing it away from the wordmark, and change its position on each of the system components so that the minuscule red globe is always fresh and new.

Brown quickly hired Pentagram partner and Art Center alumni Kit Hinrichs to collaborate with him on communicating a new era in the school's history. Together they made two critical decisions: kill the dot, and replace it with a wordmark. Upon discovering the depth of emotional attachment to the orange dot and given his own changing ideas on visual identity in an educational environment, Brown resurrected the dot. When Mendez arrived she brilliantly reconciled the two markers—the dot and the logotype—in her identity system. Then, with the recruitment catalog as the foundation piece, a flexible communications program was mapped out that scrolled like tendrils around every communication need. Mendez sought a more complex response than the traditional single-concept, clarity-filled solution. She based the system on the principles of order and vitality: order in the Eastern sense of having a solid structure to build on, and vitality through sensuality

including all the tactile and emotional levels of communication that occur beyond data.

To the recruitment catalogs she introduced air and pacing, allowing the horizontal steel-and-glass architecture to be reinforced through the format. Shifts in paper stock organize information and invite the reader to explore further. Rounded corners, vellum sheets, and eroding type were new and surprising.

The 1995 Art Center catalog was a summation of profound shifts in design, education, and thought since the early 1990s. A white "notched" spine, a black cover, and a perforated strip running directly through the center moved the book toward even greater tactility and suggested the possibility of breaking the book in two, a symbolic act that was intended as a larger comment on the state of the book in an increasingly digital world. The design intended to "speak on a very basic level that is corporeal and transcultural," Mendez explains. "The work addresses the foreign student better than something based on language and structure." Attracting international students has been among the school's creative, cultural, and financial goals for several years. That same year, Mendez completed her M.F.A. and resigned her position in the Design Office.

The Art Center's ability to evolve has made it a dynamic educational institution. Following a stint by Darin Beaman, designer and writer Denise Gonzales Crisp now holds the position of Senior Designer, adding new links to Tink Adams's original graphic chain. This is only right as the most successful enrollment propositions involve the creation of a customer relationship that extends well beyond the initial contact. Continuity is one of the most valuable aspects of profitable direct marketing, and a meaningful education.

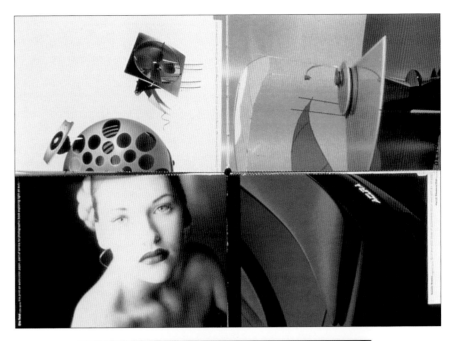

Faced with the possibility that graphic design was about to alchemize into an entirely different form as a result of new media and technology, the Design Office team tapped the idea of a "broken" or reconfigured book for its 1995 catalog. A horizontal perforation runs across all the pages of the book, bisecting headlines, creating hybrid words, and capitalizing on the interdisciplinary/multidisciplinary epidemic that has yet to loosen its hold on creative-problem solving. The highly conceptual recruitment catalog also fulfills a "weeding out" function; it clearly targets a visually sophisticated student as opposed to the average doodler.

Designs should reflect the visions, tastes, and aspirations of the target audience. This not only ensures that the recipient pays attention to the mailer, but, when multiple components are part of the package, that the reader's attention is transferred from one element to the next. Tactile additions, like perforations or unusual materials, create interesting shifts that invite the recipient to explore every piece mailed.

Personalization has been used to great effect in the Art Center catalogs. Intelligent, thoughtful messages from the president and department chairs enliven the copy and give students direct access to the philosophies and ideals they can expect from the school.

The enrollment or subscription mailer should always lead to a reply card that is simple to understand, easy to complete, preaddressed, and prestamped. For this reason, work out the reply card first. Incentives for response or expiration dates should be highly visible on the card. It should be designed as a compelling stand-alone item, able to carry all critical information, even if the rest of the mailer is thrown away.

Client: **Iowa State Fair**
Design: **Sayles Graphic Design**
Art Director: **John Sayles**
Designer/Illustrator: **John Sayles**

A dual-purpose mailer with naive graphics gathers attendees for the Iowa State Fair—"whether you want to go or show." Small size, economical paper, and a self-folding design all kept costs down. Screens were used for additional color at no additional cost.

Client: **Public Library Association**
Design: **Jim Lange Design**
Art Director: **Kathleen Hughes**
Designer: **Jim Lange**
Illustrator: **Jim Lange**

A single color conveys a strong message when paired with the right paper for this national Public Library Association's membership benefits brochure. Here, a strong PMS color and a heavy-textured, uncoated text stock make the PLA's call for membership stand out from other pieces of mail and linger in the hands of the recipient. Ten thousand of these single-color brochures were printed for U.S. distribution.

Client: **American Marketing Association**
Design: **Sayles Graphic Design**
Art Director: **John Sayles**
Designer: **John Sayles**
Illustrator: **John Sayles**

The American Marketing Association appears to have
pulled out all the stops with attention-grabbing colors for
their membership brochure. A closer look reveals a
clever, three-color design sized for a standard envelope
and letter postage.

Client: **Apria**
Design: **Landor Associates**

For an Apria Healthcare solicitation, an organic, upswept, stylized logo design makes an inviting first impression that says "we are different." The friendly approach stands out among more formal "corporate-looking" designs, and counters perceptions of the healthcare industry as indifferent and impersonal.

Client: **California Institute of Arts**
Design: **ReVerb, Heavy Meta**
Designers: **Somi Kim, Barbara Glauber**

Taking cues from the energetic atmosphere of creativity at
California Institute of Arts (CalArts), the course catalog
boasts a dazzling horizontal-line effect. The perfect-bound,
four-color glossy bulletin organizes information in a package
that reflects the tastes and goals of its target audience.

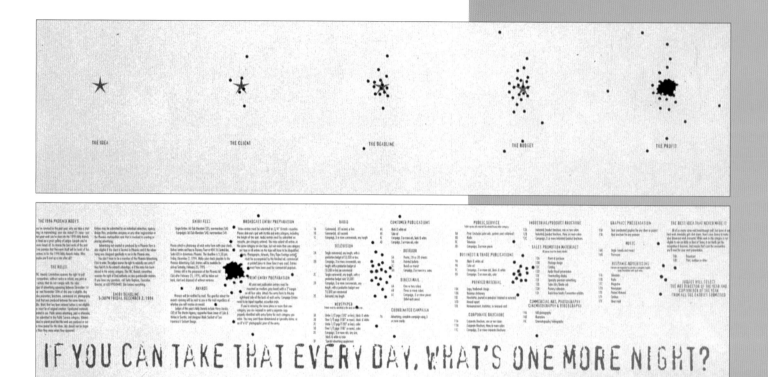

IF YOU CAN TAKE THAT EVERY DAY, WHAT'S ONE MORE NIGHT?

Client: **Phoenix Advertising Club**
Design: **After Hours Creative**
Art Director: **Russ Haan**
Designer: **Sharp Emmons**

Tactile interest ensures that recipients pay attention to a mailer, but when, as here, several intriguing components make up the package, the reader's interest follows from one element to the next. Perforations are the initial draw for this call for entries, while the headline and the simulated "target practice" hold attention and get the reader to explore the mailing further.

Client: **Bowdoin College**
Design: **Corey & Company, Inc.**

A complete information packet printed on high-quality uncoated paper stock encourages alumni to participate in the Bowdoin College capital campaign. Candid photographs of the campus and student body, black and gray duotone printing—with spot colors for emphasis—reinforce a sense of traditions upheld and the importance of participation.

Get with the Program

Client: **Sheet Metal and Air Conditioning National Association**
Design: **Grafik Communications**
Designers: **Gretchen East, Susan English, Judy Kirpich**

Imagination and resourcefulness come through as cool, confident design: SMACNA's convention and exhibitor brochure gathers strength from stock photography and PMS colors that are striking without becoming loud. Created on a budget, the project uses only two PMS colors (fuchsia and yellow), blended to project the appearance of four-color printing.

WINDOWS OF
OPPORTUNITY

OCTOBER 13-16, 1996

MAUI, HAWAII

SMACNA Annual convention and exhibitor forum

Design
FOR Response 100

Client: **American Express**
Design: **J. Graham Hanson**
Designer: **J. Graham Hanson**

The look and feel of a passport draw attention to a small
brochure prospecting for conference-goers. The compact,
portable size of the American Express conference agenda
communicates a subtle message of accessibility and for-
ward motion—as if the recipient holds a ticket to the event.
Cost savings on postage and printing is an additional
benefit of the size.

Chapter

Send a Donation

Everything in a fundraising campaign seems calculated to have an instant emotional response, to pull at the part of us that believes we can make a difference in the world. *Yes, we are part of the solution.*
"Thanks for being there," says a page from the United Way in a voice that sounds like a close friend.
"You can make a difference," whispers another. The words and pictures speak to the emotional
benefits of giving back as a source of self-expression, and as a very personal way of saying who we are.
For the direct marketer, the goal is to convince the recipient that a problem or need is of personal
significance to them, one for which a donation is part of the answer. The message is: Here,
make a difference, you'll feel good.

FUN RAISING: COCAMALAYO FOR DIFFA/CHICAGO

THE DESIGN TEAM

CLIENT — DIFFA/CHICAGO

DESIGN — CONCRETE

Designers — JILLY SIMONS

— SUSAN CARLSON

— DAVID ROBSON

Photographer — PETER ROSENBAUM

Printer — ACTIVE GRAPHICS

Paper — NEENAH PAPER

Islands have always been a haven for those seeking escape and a good time. But no one who has sought sanctuary among pendulant flowers and luxuriant palms ever imagined that a tropical fantasy able to indulge frivolity and philanthropy could be found at a June ball on the windy shores of Lake Michigan.

The island in question—Co`ca`ma`lay`o—was, of course, fictitious. Jilly Simons, principal of Concrete, a Chicago-based graphic design firm, suggested an island paradise theme to lure 650-plus donors to a $250-a-head dinner for DIFFA (Design Industries Foundation fighting AIDS). She concocted the exotic location's name from the combined surnames of the ball co-chairs: Patsy Callahan, Mitchell Cohen, and Gregory Maire. Founded in 1984, DIFFA is an innovative fundraising organization that has granted more than $20,000,000 to over 900 organizations. One of eighteen chapters nationwide, DIFFA/Chicago distributes funds to Chicago area AIDS service agencies that provide assistance to men, women, and children affected by AIDS and HIV-related illnesses. Working closely with then executive director Dennis Krause, Simons took an overtly festive approach to the creation of a fundraising mailer that turns the wrenching subject of acquired immune deficiency disease into something joyously seductive and profitable. For the fourth year in a row, the completely underwritten event netted in excess of $200,000. In fact, the initial letter and Save the Date card so captivated the target audience that the event sold out before the actual invitations were mailed.

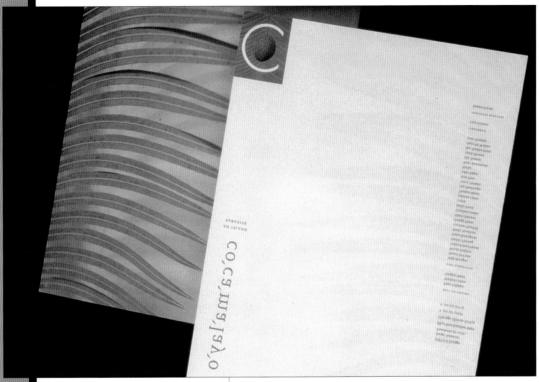

The letterhead and Save the Date card (not shown) introduce the island paradise theme of the event. The bold black-and-yellow card communicates urgency, while underscoring the personal benefits of giving by telling the recipient that only pledges accompanied by a check and received by a specified date will be acknowledged in the souvenir book.

While it's easy to dismiss the vibrant mailer that unfolds into a succession of lime greens and banana yellows as merely another elitist dinner dance invite, one should beware of condescending to the mere pretty picture. The bloom of health conveyed by flowers, fruits and leaves are a graphic splendor that arises from need, not indulgence. "More than anything this event is a way for DIFFA to celebrate their constituency and give them a round of applause," says Simons. "It does this by evoking all the things that have to do with a beautiful island paradise. It is tongue-in-cheek because we know things are never perfect, but when you [visually] smell cinnamon, feel the sun, eat fresh fruit, you half convince yourself that you are there. We all strive for perfection and feel uplifted by it." The advantages of this approach depend on the cause. In DIFFA's case

it was a way of answering the unspoken question in the mind of the donor, "Why Should I?" The communication stream, which begins with the Save the Date card and ends with the momento guests receive as they depart, provides both rational and emotional answers to that question. Perhaps it is simply easier to motivate others by fun than dread. According to Simons, "The fear factor is an enormous motivator, but not when you are selling a party. If you are asking for money for people starving in Ethiopia should you plan a party where you serve caviar? That would be neither tasteful nor appropriate. Part of the success of the event is the pressure you put on yourself as a contributor. DIFFA recognizes that it is hard work to make the event come off so the celebratory spirit isn't just gratuitous." The spirit of giving back permeates the culture of

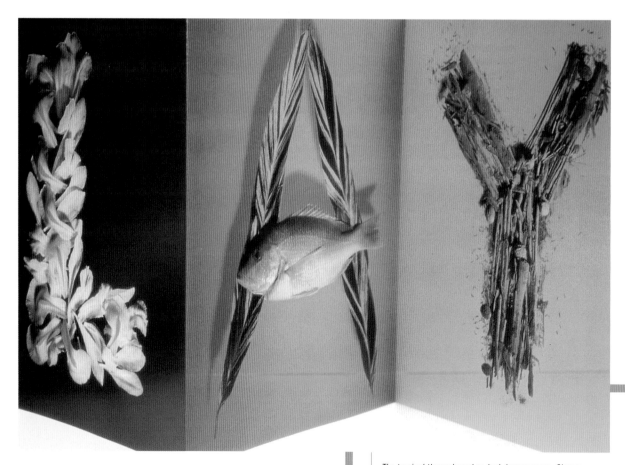

The tropical theme based on lush imagery was, Simons explains, a chance to say, "Wouldn't it be nice if everything could be utopia? Wouldn't it be wonderful if all the funding and efforts could turn this disease around?"

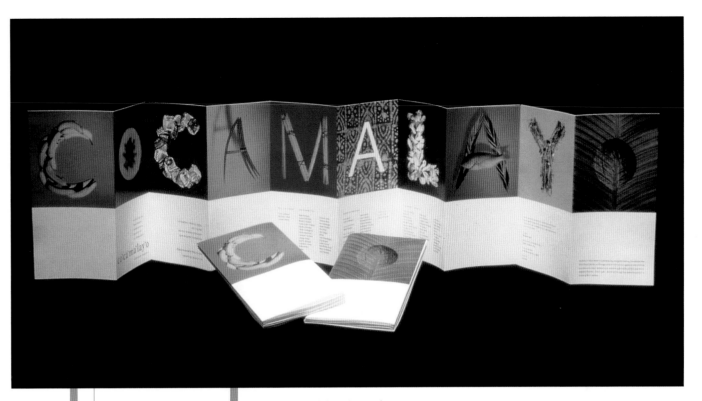

It is the little things that mean a lot. The creative team made inventive use of photography, crafting letters from fruit, flowers, spices, and even a fish to spell out the name of the fictitious Cocamalayo island. They made the most of a hot color palette to tell a story that is clear and recognizable.

the Chicago chapter, and has the effect of raising the bar at every level so that the black-tie gala was recently ranked as one of the city's top events by *Chicago* magazine.

Meeting the budget was as important to Simons as the evocation of a mood. In past years, DIFFA had mailed large posters that were surcharged so there were concerns about lowering the postage rates. She took scrupulous care to get the cost of the mailing down by, where available, choosing a highly durable, featherweight Neenah paper stock called Kimdura for elements like the invitation. She also took the rest of DIFFA's cost-saving concerns to heart. All the creative services, photography, paper, and printing were donated. While this is certainly not a standard business practice for other direct mail fundraisers to emulate, it brought the total costs down significantly, but meant that one client gradually expanded into three: DIFFA, the printer Active Graphics, and the paper company Neenah. "The thing I feel most proud of was the way I was able to

talk to the other contributors and get them emotionally involved in the cause. I was as committed to serving their needs as contributors as much as was DIFFA's. Neenah would probably have given me the paper anyway, but I promised them a high-quality piece in return that would give them a chance to showcase their product to an audience they wanted to reach. In that way I was further able to use my craft to donate to DIFFA. The DIFFA event is unique because it asks, 'What are you prepared to sacrifice?' in all the ways that it might be interpreted. It becomes a matter of dedication."

Chicago is home to The Merchandise Mart, the annual location for NeoCon World's Trade Fair, the contract furnishings industry's premier annual event. DIFFA's ball has traditionally been timed to coincide with NeoCon when the city is flooded with major players in several fields of design, thus extending the event's potential reach. One of the earliest groups to be personally and professionally impacted by

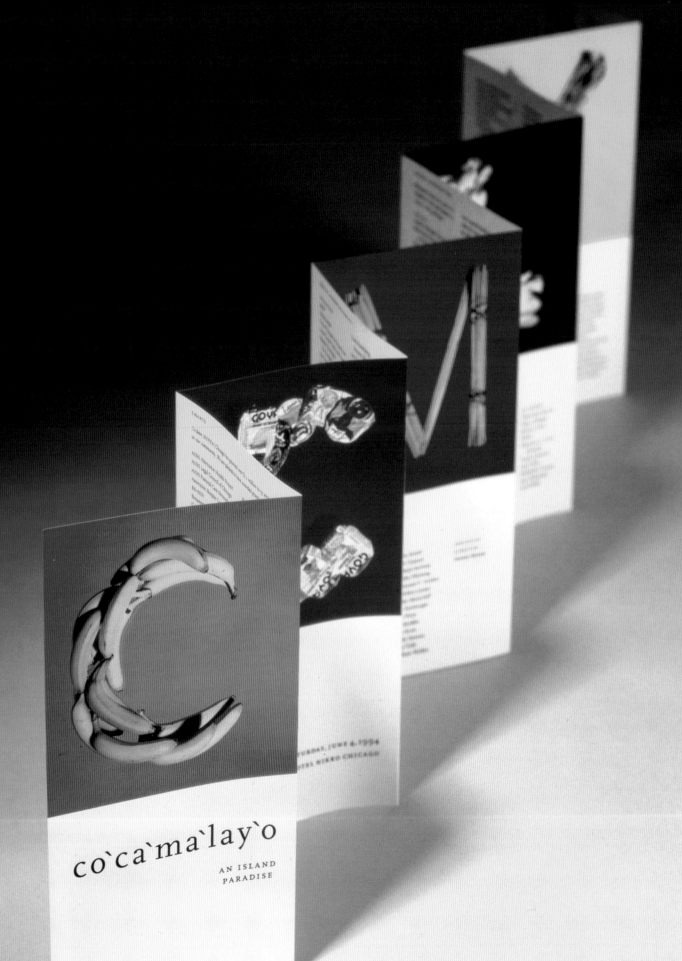

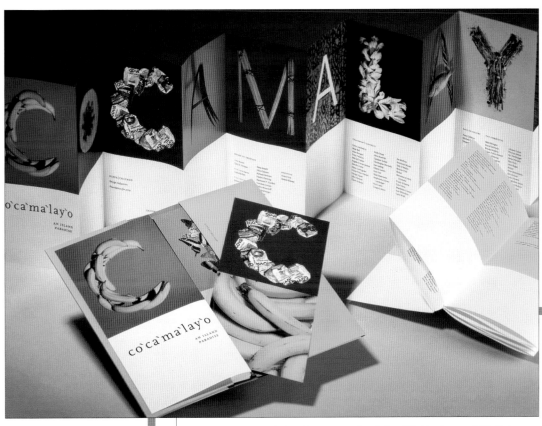

Every element is part of a learning system, or "curriculum," that teaches one "bit" of infor-
mation at a time as it asks for a donation. Each message builds on the lessons of the previ-
ous one, helping convince donors of the worthiness of the organization, and ensuring that the
communication is simple, clear, and focused.

the virus, designers are a highly sensitized and well-informed audience. "Part of what worked is that this is such a responsive constituency," Simons acknowledges. "Many of the people in this critical audience are spending money because of their own losses. DIFFA feels an obligation to give back to this audience an event as good as the support it receives. That is why it has to be special."

First, 3,000 letters and Save the Date cards were mailed. In poured the R.S.V.P.s. Next, an invitation to a kick-off party was mailed to sponsors, contributors, and key donors. In short, everyone was needed to make the event a success. The kick-off party—a twenty-five-dollar-per-person event that included a raffle—was celebrated at the Banana Republic store on Michigan Avenue, which neatly

corresponded to the exotic theme of the sixth annual gala event. Lastly, the invitations, reply cards, and raffle ticket registrations were mailed out. A billfold featuring postcards of outtakes from the project, and a souvenir brochure that was inexpensively produced by overprinting donors' names on the back side of extra invitations, were handed to guests as they left the event. The island-style post-cards took the entire theme a step further, again via the mail. Personal identification is one of the truths any fundraiser seeks to cultivate. Another truth is that in our culture, resources often equal survival for the myriad worthwhile causes that depend on the mail as a vehicle for obtaining support. The hope is that by exercising those resources well, charitable organizations can inspire donors to give away their own resources.

Client: **Women in Military Service for America**
Design: **Lautman & Company**
Art Directors: **Fran Jacobowitz, Holly White**
Designer: **Concord Litho Group**
Photographers: **Various WWII poster artists**
Other Pertinent Credits: **Special recognition to Mel Meehan of Meehan Military Posters**

This special-edition calendar seeks to raise funds for a memorial honoring women who have served in the military beginning with the American Revolution. Profiles that include quotes from contemporary women in the military service are contrasted with inspiring poster images from the 1940s that glamorize the war effort and women in the military.

Client: **United States Holocaust Memorial Museum**
Design: **Lautman & Company**
Art Director: **B & G, Inc.**
Designer: **B & G, Inc.**

Moving personal testimonials from American Holocaust
Liberators and small, simulated snapshots from
1945 featuring images of concentration camp victims
following the Liberation give a poignant note to an
appeal to join the United Holocaust Memorial Museum
in Washington, D. C. In a subsequent mailing, an
exhibition floor plan allows the recipient to "walk
through the museum."

Client: **National Museum of Women in the Arts**
Design: **Lautman & Company**
Art Director: **B & G, Inc.**
Designer: **Rick Aleman of B & G, Inc.**

Unusually lavish, four-color reproductions of drawings,
paintings, photography, books, and performing arts
are essential for communicating the level of achieve-
ment of women in the arts. This heightened awareness
of their artistic visions serves as a powerful draw for
luring prospective members to a museum dedicated to
women in the arts.

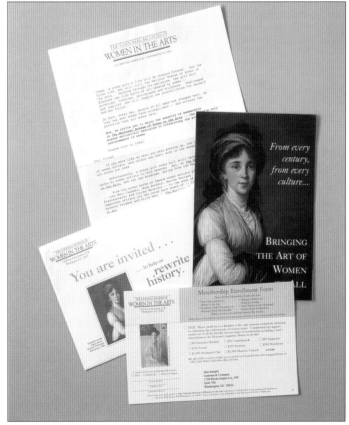

Client: **Japanese American National Museum**
Design: **Lautman & Company**
Art Director: **B & G, Inc.**
Designer: **B & G, Inc.**

A compelling tale and a sense of belonging begin on the envelope as an enticement to become a part of the mission to preserve the cultural identity and ethnic heritage of Japanese Americans through a membership to the Japanese American National Museum. An enclosed letter from Senator Daniel Inouye, who was badly injured during World War II fighting for America, raises the urgency of the cause from one of the most shameful moments in American history to one of personal freedoms and constitutional rights.

Client: **United States Holocaust Memorial Museum**
Design: **Lautman & Company**
Art Directors: **Adrianna Barbieri, Barbara Green of B&G, Inc.; Kay Lautman**
Designers: **Adrianna Barbieri, Barbara Green of B&G, Inc.; Kay Lautman**
Writers: **6" x 9"—Kay Lautman; #10—Dennis Lonergan**
Special Recognition: **Bennett Samson and Genya Markon at USHMM for historical photographs**

The United States Holocaust Memorial Museum is considered one of the most compelling memorials to human devastation. It targets former members with the "Year in Review," a report that emphasizes how the museum's resources are used to shed light on the Holocaust, a prime concern of supporters. Another mailing to existing members includes an audiocassette of oral history that begins with the tantalizing request to read the letter before listening to the tape in preparation to better hear the interviews with eye witnesses to the Holocaust.

Client: **United States Holocaust Memorial Museum**
Design: **Lautman & Company**
Art Director: **Fran Jacobowitz**
Designer: **B & G, Inc.**
Photography: **Children of Terezin**
Other Pertinent Credits: **Original artwork provided by The Jewish Museum in Prague**

This three-part calendar program designed to provide information and raise funds for the United States Holocaust Memorial Museum focuses on a sensitive collection of drawings and paintings done by Jewish children while in concentration camps. The first mailing is a "negative option" letter, which informs the recipient that a gift has been reserved for them in their name and will be mailed unless they request otherwise. Part two is the calendar filled with images that speak of pain and longing but also of perseverance and hope. The final mailing is a follow-up request.

Client: **House of Ruth**
Design: **Lautman & Company**
Art Director: **B&G, Inc.**
Designer: **Caroline Pineda**
Copywriter: **Connie Clard**

The letter shares the moving, real-life story of Sheila—a homeless and unemployed mother of three. Sheila's story was powerfully told with the hope of raising funds for the House of Ruth's new counselor program for women who face chronic unemployment after leaving their abusive households. The appeal uses everyday facts the recipient can relate to, and gently but compellingly convinces him or her of the critical importance of this organization.

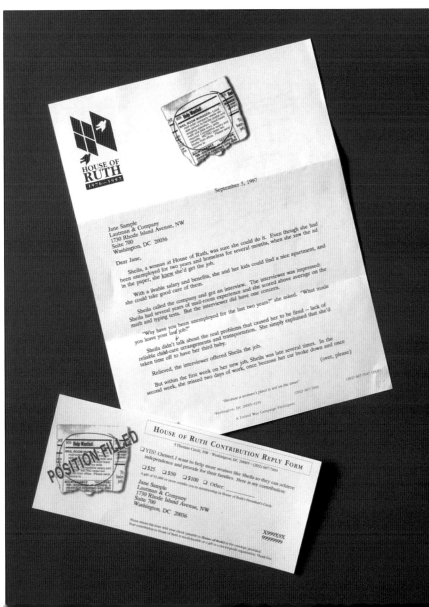

Send a Donation

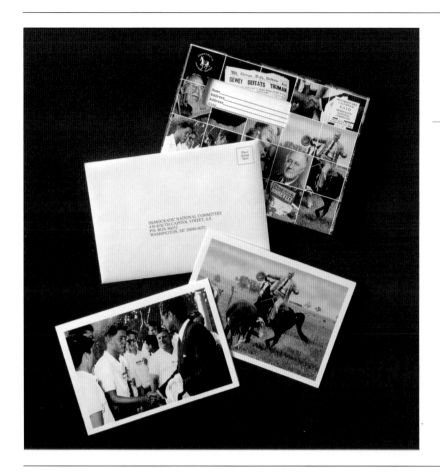

Client: **Democratic National Committee**
Design: **Thomas Drymon Design**
Art Director: **Tom Drymon**
Designer: **Tom Drymon**
Copywriter: **Lisa Selner**

A nostalgic box of note cards featuring hand-colored photographs of decisive moments in the history of the Democratic Party speak directly to the strong partisan nature of this primarily over-sixty-five donor base, and gives the impression of a substantial gift. The response was 281% higher than the average rate for all appeals to the DNC in the previous year.

Client: **Civil War Trust**
Design: **Malchow, Adams & Hussey**
Art Director: **Carolyn Coon**
Designer: **Carolyn Coon**
Copywriter: **Jim Hussey**

The Civil War Trust raises private funds to purchase and preserve endangered Civil War battlefields. This mail-piece stressed the importance of the battle and the historic texts the audience typically reads. Interesting yet inexpensive premiums tied to the mission of the organization were included. This package alone increased the Civil War Trust's donor-base by 40 percent.

Client: **Whitman-Walker Clinic, Washington, D.C.**
Design: **Malchow, Adams & Hussey**
Art Director: **Carolyn Coon**
Designer: **Carolyn Coon**

Head Writer/Senior Creative Manager: Lisa Selner
The Whitman-Walker Clinic is a health and social
service organization for people with AIDS or HIV. To
improve the poor performance of direct mail during
the summer months, the package asked the recipient
to write a note of encouragement on the Hope Card
to be shared with a clinic patient and return it with
a donation. The gross income increased over typical
summer appeals by 50 percent.

Client: **Democratic National Committee**
Design: **Malchow, Adams & Hussey**
Art Director: **Carolyn Coon**
Designer: **Carolyn Coon**
Photographer: **Dan Kessler**
Copywriter: **Jim Hussey**

Capitol Hill artist Dan Kessler was commissioned to
do the original painting of the White House that would
be reproduced on this fundraising/cultivation package.
The package also included a letter on the history of
the White House and the importance of the Democratic
National Committee's work, as well as a certificate
on the history of the print signed by the artist, the
President of the United States, and the leadership
committee of the DNC.

Send a Donation

Client: **Clinton/Gore '96 Primary Committee**
Design: **Malchow, Adams & Hussey**
Art Director: **Carolyn Coon**
Designer: **Carolyn Coon**
Photography: **Time Magazine**
Copywriter: **Jim Hussey**

Donors were encouraged to display the poster and bumper sticker enclosed in the package and return a donation to help President Clinton and Vice President Gore win re-election in 1996. A reply device asked the donor to return confirmation of delivery. Not only did this generate an unheard-of 5.11 percent response, but nearly half a million posters and bumper stickers were distributed across the country.

Client: **Defenders of Wildlife**
Design: **Thomas Drymon Design**
Art Director: **Tom Drymon**
Designer: **Tom Drymon**
Photographers: **Jim Brandenburg, National Park Service; Richard Forbes, U.S. Fish and Wildlife Service**
Copywriter: **Mary Conley**

This package was patterned after mail-order film developing envelopes. Enclosed were photos of the wolves across the country that Defenders of Wildlife donors support with their contributions. The hand-written font used in addressing the envelope gave the package a unique personalized look.

Client: **Defenders of Wildlife**
Design: **Thomas Drymon Design**
Art Director: **Tom Drymon**
Designer: **Tom Drymon**
Photographers: **Tom and Pat Leeson, Art Wolfe,**
Erwin and Peggy Bauer, John Shaw, Barth Schorre,
Tom Kitchin, James Watt
Copywriter: **Lisa Selner**

The success of the calendars is directly tied to the
beauty of the design and the perceived value. High-
quality photographs were presented in a clean,
readable design. A follow-up self-mailer was sent to
encourage a greater response. The common use of
inexpensive gifts, such as calendars, post cards, and
booklets, is designed to elicit the "we gave you
something of value, now it is yous turn…" response.

Client: **The Renaissance Society**
Design: **Concrete**
Designers: **Jilly Simons, David Robson**
Photographer: **Dan Rest**

The Renaissance Society, a contemporary arts organ-
ization, needed an invitation for its black-tie
fundraising benefit. (After + Before is a celebration
of the director's twentieth anniversary with The
Renaissance Society.) The typographic treatment and
the split portrait of the director allude to the event
taking place after the accomplishments of the past
20 years and all of the successes to come.

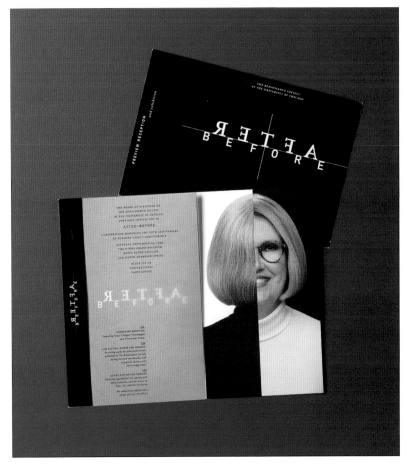

Send a Donation

Client: **The Renaissance Society**
Design: **Concrete**
Designers: **Jilly Simons, Susan Carlson**
Copywriters: **Various**

This invitation to The Renaissance Society's annual fundraiser invoked the greatness of Chicago institutions. Various Chicago personalities were quoted on their feelings about the city as their hometown, adding a spirit of civic pride. Materials used echo Chicago's industrial prowess and classically Mid-western-utilitarian perspective. The butcher paper communicates the city's heritage as the hog-butchering capital of the world; the chipboard backing and industrial staple allude to the toughness and brass-tacks sensibility of Chicago and its denizens. The chipboard is printed with the words, "METER BROKEN." Chicago is notorious for broken parking meters, and the sign is meant to be detached from the invitation for the recipient to save for "emergency" use in case of extreme aggravation or shortness of change! The overarching message is: Give back to what makes the city great—its cultural institutions.

Client: **United Way**
Design: **Hornall Anderson Design Works, Inc.**
Art Director: **John Hornall**
Designers: **John Hornall, Jana Nishi**

Dramatic, black-and-white computer-manipulated photos contrast with a warm color palette to give the brochure both a sense of urgency and hope. Each piece of this donation kit features the testimonial giver's signature along with additional signatures from United Way services recipients, introducing the human touch and bringing critical issues to a personal level.

Client: **The Gay and Lesbian Task Force**
Design: **M & Co**
Creative Director: **Tibor Kalman**
Art Director: **Stefan Sagmeister**
Illustrator: **Tom Walker**
Other pertinent credits: **Keira Alexander**

An invitation arrives to a fundraising event from The Gay and Lesbian Task Force in a small box with a banana and a plum. That's the witty recipe for not only mailing a momento before the event, but also for overcoming the maddening challenge of sending ripening fruit through the mail.

Chapter 7

Make a Purchase

Mail-order catalogs today are part convenience, part wish-book, and part magazine with a distinct editorial view. *Catalogs make their way into millions of mailboxes each month by employing several of the previously defined strategies: create awareness, build a relationship, gather information, generate trust, and, finally, make a purchase. The appeal of mail-order selling to the direct marketer is its purity, a neat fiscal transaction that is very efficient, very tangible. It also represents direct marketing at its most challenging and complex because consumers have come to expect more than just merchandise. They want people, places, and a mythical image of life that is happy, harmonious, and just a credit card away. As such, it is the ne plus ultra of commercial direct marketing, stretching designers' abilities to their limits. It is also the most quantifiable of all direct marketing practices, measured in terms of dollars sold per thousand catalogs mailed. On average, the adult population of the United States buys over fifty billion dollars worth of goods by mail. But let us not go on, since too many facts would spoil mail order's crucial mystique—that you alone with your pages of merchandise, are the only customer in the world.*

SETTING SALES: OCEAN CATALOG

THE DESIGN TEAM

CLIENT — AAMIR AHMAD

— OCEAN HOME SHOPPING LTD.

DESIGN — GAVIN JOULE DESIGN

Creative Director — AAMIR AHMAD

Art Director — SEAN GALLIGAN

Designer — GAVIN JOULE

Copywriter — MICHAEL HARVEY

The mail-order offer, be it print or electronic, is the equivalent of store, fixture, merchandise, service, cash, all in one. It builds on all the lessons of previous chapters to stretch the direct marketer's creative and strategic capabilities to the limit, making it the most challenging and complex form of direct mail. For the customer, the total offer—product, presentation, service, and financing—has to be better than okay. It has to promise something relevant and timely in a manner they cannot get elsewhere. Not only are the results irrefutably measurable in dollars per thousands of offers mailed, but the offer alone must succeed in persuading the consumer to make a purchase, convincing him or her that in exchange for a leap of faith their every expectation will be fulfilled. Fail to meet those expectations and the customer is unforgiving. Exceed them, and the sweetest rewards of direct marketing are yours.

Ocean—the name tells you right away that this is a catalog for urbanites who appreciate the nuances of a well-marketed concept. With over twenty percent of the British population located in London, and over seventy percent living in the top five urban centers, such a business strategy has real merits. The British have never been short on style, but in terms of direct marketing the country has developed much like species of the Galapagos Island—in isolation and with unique environmental factors. A lack of external marketing pressures and a unique set of local conditions have cultivated an atypical environment. (British mail-order strategies and tactics have been largely eclipsed by the evolution of direct marketing in other countries, particularly North America). Add to the equation the emergence of a new niche in the U.K.—home furnishings via mail order— and you have the seeds of Ocean's identity.

From the outset, Ocean has sought to offer a lifestyle experience to the consumer rather than just a collection of objects for the home. On a Fall cover, an inviting armchair and throw take center stage and equate the feeling of comfort with "the good life." Beyond the desire this cultivates in the recipient, Ocean succeeds by bundling strategic services—gift wrapping, next day delivery, free no-quibble returns, twenty-four-hour free phone orderline—and advertising them up front.

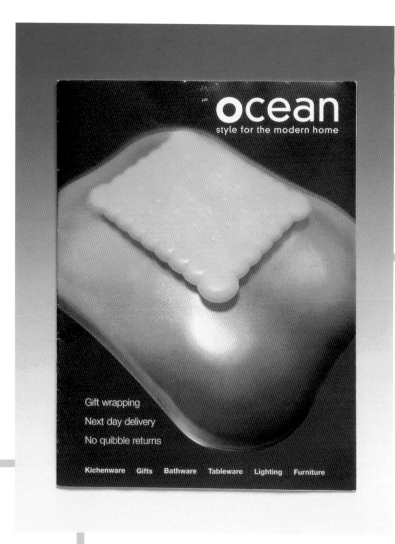

ocean
style for the modern home

Gift wrapping
Next day delivery
No quibble returns

Kichenware Gifts Bathware Tableware Lighting Furniture

Designs should speak to a clearly segmented market. Here, a vibrant palette brings an air of exuberance to the cover's pared-down aesthetic. A blown-up biscuit box has just the right irreverent appeal for a target market that appreciates design excellence. Note the emphasis on services.

But the name Ocean also suggests breadth and depth. Not a bad metaphor for a business seeking to be thought of as the source for a broad range of classic modernist objects. Ocean sells contemporary kitchenware, bathware, tableware, lighting, furniture, gifts, and home accessories. The majority of the catalog's clean, simple offerings are from small British companies and recognized names in the European housewares market, such as Alessi, Philippe Starck, Bodum, and Rosle. "Ocean does not offer particularly unique products, or even low prices," says Aamir Ahmad, CEO of Ocean. "Instead we offer our customers a collection of tasteful and classical products, not trendy items that will come in and out of fashion. And we offer these to them with great convenience and service. This sets us apart

from the competition and lends instant credibility." Their covers say it all. Next-day delivery at no additional cost. No-quibble returns. A twenty-four-hour toll-free order line, something practically unheard of in England where even the largest mail-order companies offer only nine-to-five, Monday-to-Friday phone service. Gift wrapping is available. And, significantly, most credit cards are accepted.

The challenges for Mr. Ahmad are many. With a management consulting background and considerable experience in retail and home shopping, including a stint at Laura Ashley, Ahmad first identified a niche in the expanding home furnishings via the newly evolving mail-order market. He looked to other countries and determined that for

Ocean to acquire customers from local merchants—his primary objective—he would have to bundle together products, services, and other value-added benefits to form an offer unavailable through any other means. Most direct marketers, and merchants in general, overlook the persuasive impact of the product/service/credit bundle on the consumer.

Several independent factors had converged in England to exert pressure on the old paradigms and create new direct marketing opportunities. These included the deregulation of banking and the subsequent proliferation of credit cards, improvements in the British parcel system technology, and an increase in the number of women in the workplace resulting in greater discretionary income and a need for convenient shopping. To be successful, though, Ahmad would have to change the long-held perception in the U.K. that catalog shopping consists of cheaply made products, disreputable vendors, poor fulfillment, and bad service. As other nations advanced beyond the primordial stages of direct marketing, Great Britain, due in part to its geography, remained mired. (If America Online U.K. is any indication, at the moment

there are no shopping sites listed in the U.K., compared with thousands of sites available in North America and hundreds throughout Europe.) Ocean strives to bring British mail order into the twenty-first century by tampering with the elemental mix of tactics the current category captains rely on, and by reeducating young aspirational consumers about what mail-order shopping can mean.

Ocean's greatest challenge is to attract customers who would have previously looked askance at direct mail. The 1997 Holiday catalog was mailed to more than 300,000 individuals, sizable by U.K. standards. However, fewer than 40,000 of those customers had previously purchased from Ocean, and most of them were new to mail-order shopping. It is from the high purchase rate of these prior buyers that Ocean will derive profit. Ocean's financial success lies in the acquisition of new upscale mail-order customers. List rentals, a staple in other nations, are not particularly effective for Ocean. The only lists that would be valuable to Ocean are those of prior high-end mail-order buyers, and these are virtually non-existent in the U.K. To acquire customers, Ocean

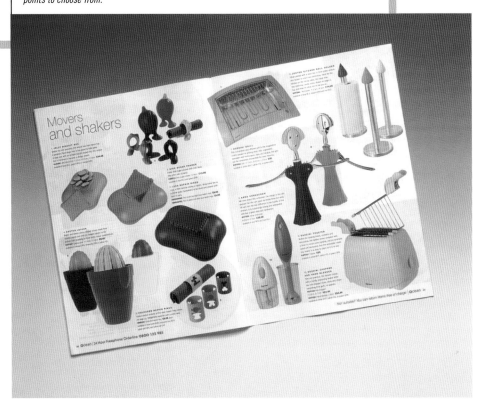

Colorful tabletop items silhouetted against a white background juice up Ocean's accessories pages and encourage impulse purchases by giving customers a range of times and price points to choose from.

Most direct marketers overlook the persuasive impact of the product/service/credit bundle on the consumer. Those who have applied these elements to their strategic advantage have been remarkably successful. For example, L. L. Bean offers a perceived standard of unique service. American Express Merchandise Services promises the ability to acquire items beyond their cardholders' means via interest-free deferred payment. Lands' End stresses the quality behind the brand. If a marketer eliminates all the reasons for a customer to say no, the only answer left is the desired response.

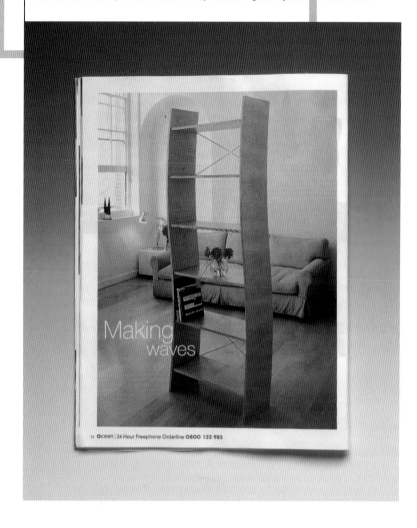

must create awareness and entice readers to request a catalog. Ocean advertises in aspirational shelter and lifestyle magazines with a message focusing on lifestyle, convenience, and credit. Plus, they have made a strong public-relations push with editorial that generally includes the toll-free phone number.

Desire is a distorting emotion. It can make us go against our logical judgment; it can allow us to lose all reason. These powerful emotions can turn the desire to feel good about one's home and self into something palpable and real—and can easily be triggered by the sight of a catalog filled with coveted objects. For a few brief moments we perceive ourselves as the owner of each product that catches

our attention, try them on mentally for size, accepting/rejecting until the last page of the catalog has been consumed. Ocean uses a cadre of services, conveniences, and easy payment terms to seductively eliminate any obstacles in a customer's mind. "Just pull out your credit card and pick up the phone any hour of the day; we'll even pay for your call. Your new acquisition will be displayed in your home the day after tomorrow. If you don't like it, you can even return it." Ocean's success or failure lies in convincing customers that the satisfaction of desire is only a phone call away.

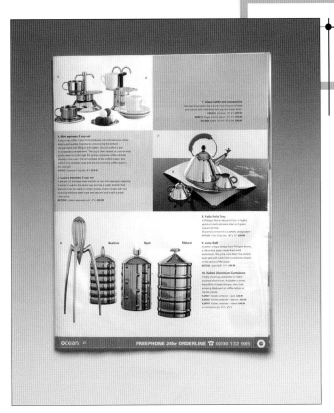

Recognized brand names from Alessi to Philippe Starck facilitate the purchase decision by reducing the risk of disappointment on the part of the customer. Blocks of color draw attention to valuable information and relieve the neutrality of a page composed of objects in aluminum and steel.

Sight bites of information, bold color, and simple shapes add up to an attention-getting spread filled with witty solutions for a range of kitchen activities.

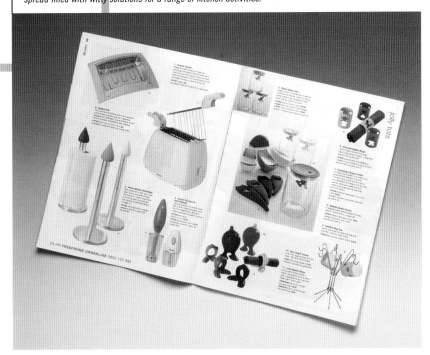

One key to catalog success is the acquisition of new customers. Many catalog companies actually plan to lose money on their early mailings. They consider this acquisition cost an investment in the long-term relationship they seek to build with their customers. Tracking response, as with all direct marketing, is critical since each "prior purchaser" represents the goose that will lay the golden egg.

The most sophisticated direct marketers create a series of "longitudinal offers" designed to establish an ongoing rapport with their customers. Some catalog companies have a different stream of catalogs ready to mail to recipients based on factors such as when in the longitudinal series the first response occurred, what item was purchased, what the method of payment was, etc. The overall impression made by the offer, products, or services, as well as the quality of fulfillment and customer service all affect the chances for further responses.

Make a Purchase

gallery

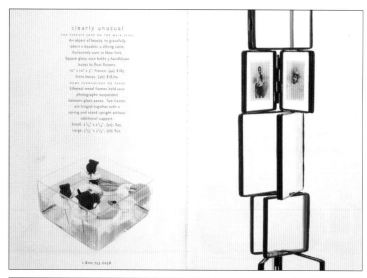

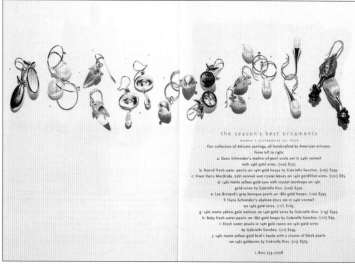

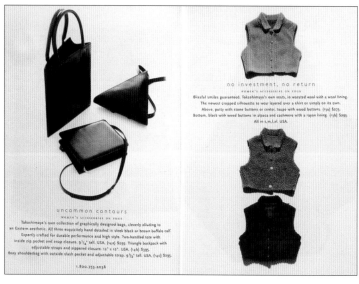

Client: **Takashimaya New York**
Design Firm: **Design: M/W**
Art Director: **Allison Muench Williams, J. Phillips Williams**
Copywriter: **Laura Silverman**
Photographer: **Carlton Davis**

The holiday catalog for Takashimaya, the innovative East/West department store, relies on beautiful photography of precious home furnishings and accessories to capture the spirit of the holidays. The captions, printed in metallic type, are witty takes on holiday sayings; precious earrings, silhouetted on a matte paper, are described as "the season's best ornaments." Wrapped with a cover photo of a pink, red, and green bouquet of petals and fruits, the catalog offers an alternative to the usual red and green holiday color scheme.

Client: **Takashimaya New York**
Design: **Design: M/W**
Art Director: **Allison Muench Williams, J. Phillips Williams**
Copywriter: **Laura Silverman**

Takashimaya has a reputation for lyrically balanced merchandising displays combining exquisite objects from opposite ends of the globe, and their catalogs are no exception. Plenty of blank space, discrete type and subtle textures send a message upscale sophisticates appreciate. With details like the hand-tied bow along the spine, the store lets luxury fly.

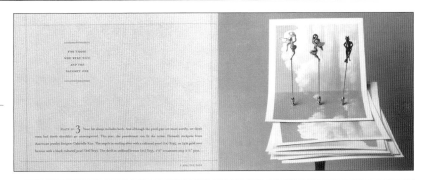

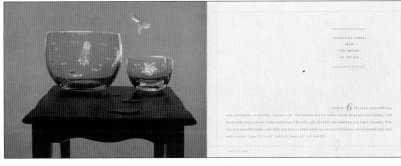

Client: **Starbucks Coffee Company**
Design: **Hornall Anderson Design Works, Inc.**
Art Director: **Jack Anderson**
Designers: **Jack Anderson, Julie Lock, Leslie MacInnes, Julie Keenan**
Illustrator: **Julia LaPine**
Photographer: **Darrell Peterson**
Copywriter: **Pamela Mason-Davey**

Warm illustrations and photography in these direct mail catalogs for the Spring and Summer season of 1994 convey the image that Starbucks is the coffee expert. They also need to represent the Starbucks "experience," capturing the Starbucks culture and re-creating the store experience, while maintaining visual continuity with other Starbucks communication pieces.

Starbucks Summer Catalog 1994

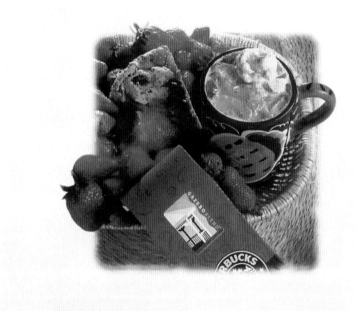

Client: **SunDog, Inc.**
Design: **Hornall Anderson Design Works, Inc.**
Art Director: **Jack Anderson**
Designers: **Jack Anderson, Davis Bates**
Illustrator: **Todd Connor**
Photographer: **Darrell Peterson**
Copywriter: **Julie Huffaker**

For this outdoor accessories company, the primary objective was to create a catalog that would, on an extremely low budget, reposition SunDog as a new company with a new product line based on technical expertise. As a cost-saver, the design team recycled and touched up existing line drawings of products that SunDog had used in an earlier catalog. The copy was written to retain a travel journal character. Editorial pages had underprints of natural elements such as shells, leaves, and pine cones, motifs that were also picked up as ornaments behind the page numbers. The product pages were printed in two colors (black and white) on a gray recycled paper that was enclosed in a four-color, double-gated sheet. Once printed, the parts were stitched together. Warm photographs were used to lend the catalog a more user-friendly appeal. Paw prints through sand on the front and back covers playfully reflect the company's name, SunDog.

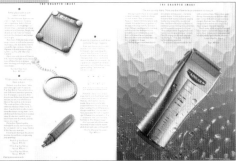

Client: **The Sharper Image**
Design: **In-House Agency**
Art Director: **W. Nelson**

This Star Wars cover, coinciding with the re-release of the film series, launched a new quadrant design both inside and outside the Sharper Image catalog. The graphically arresting, high-tech product line demonstrates the target audience's—young, male consumers with discretionary income—affection for gadgets as an expression of masculine taste.

Make a Purchase

Client: [T-26] Digital Type Foundry
Design: Segura, Inc.
Art Director: Carlos Segura
Designer: Carlos Segura

Typessence! As if the 400 typefaces represented by Carlos Segura's [T-26] digital type foundry catalog weren't enough, it also comes encased in metal, contrary to all efforts to make things sent through the mail as light as possible. Segura has said, "I like fonts that have a sense of their own body language, that paint a page and turn it into something else." The same can be said of his approach to catalog design.

Client: [T-26] Digital Type Foundry
Design: Segura, Inc.
Art Director: Carlos Segura
Designers: Carlos Segura, Susana Detembleque, John Rousseau

Segmenting and profiling your target market is crucial when the goal is to deliver a message of true relevance to your customers. And the easiest of all target markets to speak to is oneself. Graphic designer Carlos Segura need look no further than his own creative profession for inspiration. His font kits are designed to be "little gifts to our customers." Full of large printed catalogs and elegantly rendered cards, the total package is intended to bring energy, wit, and invention to other graphic designers.

Client: **[T-26] Digital Type Foundry**
Design: **Segura, Inc.**
Art Director: **Carlos Segura**
Designer: **Carlos Segura**

[T-26] is filled with contributions by people without any formal design training, bringing a wealth of diverse aesthetics to Carlos Segura's Digital Type Foundry catalog. "Artists like Jean-Michel Basquiat and Keith Haring would never have seen daylight if we had all been of the mindset that art should only be done by classically trained people." He regularly releases limited edition "T-bags," screen-printed muslin sacks containing the latest supplement to the type collection plus quirky promotional items.

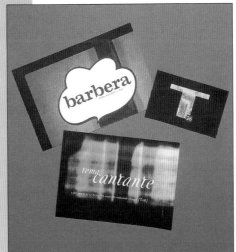

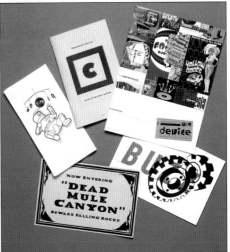

Make a Purchase

gallery

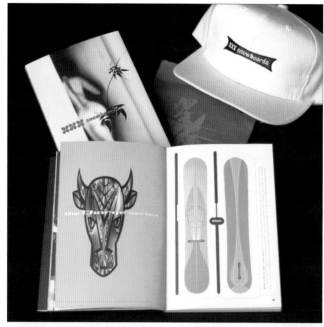

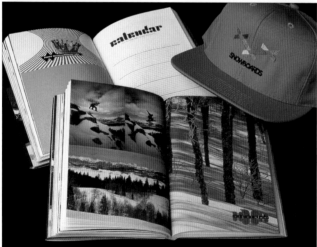

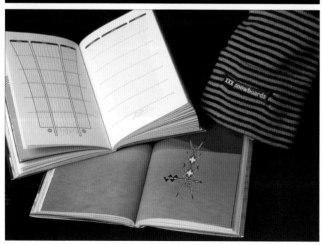

Client: **XXX Snowboards**
Design: **Segura, Inc.**
Art Director: **Carlos Segura**
Designer: **Carlos Segura**
Photographers: **Carlos Segura, Colin Metcalf, Tony Klassen**

To promote a new line of jackets and boards for XXX Snowboards, Carlos Segura took his bearings from the materials and climate of the sport. Into the wet, cold world of winter mountain sports he injected the needs of snowboarders. The result is a hat and resource book on the sport, filled with tips, a calendar, and a date-book, and information vital to professional boarders. These arrived wrapped in snug, water-resistant bags stitched from remnants of the jackets themselves.

p. 26

Client: **The J. Peterman Company**
Design: **In-house design department**

Against industry adages, J. Peterman applies the romantic elegant style of a bygone era to its product line and catalog design. Short, snappy narratives and wash illustrations are a fluent expression of the catalog's rich nostalgic style. Apparel and home furnishings gathered from all corners of the globe create a sense of connoisseurship for everyday living that builds a connection between the consumer and the J. Peterman lifestyle.

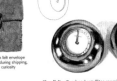

...ood piano deserves-
...e Pfeiffer. Or this frame.
(№. 02A4064).
...mum image size 6-1/2" x
...maximum image size 9" x
...en-tinged glass, elegant
...n strut, oversized wing
...designed to exaggerate
...licacy of whatever you
... of it. Imported.

Frame comes in felt envelope
to keep it safe during shipping,
and to provoke curiosity
afterwards.

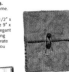

Simplicity. Overhead satellites roaming, observing, compiling, briefing. Buried deep in Climatic Data Center, computers analyzing at 200 million calcs per second. All in the name of telling us how to dress each morning. You, on the other hand, from the comfort of your 1920 Hoffmann rocker, with an unconscious glance at your highly polished pewter wall-mounted Georg Jensen thermometer, know at a glance whether (or not) to put on a sweater, or just another log.
 Georg Jensen Thermometer (№. 02A4084). Price: $110. Designed by Andreas Mikkelsen for Georg Jensen, Denmark. Set accurately at the factory. No need for subsequent adjustment. Imported.

Proper moments for examining the clock. To keep from talking to the floor. While detecting faint aromas coming from the kitchen. When thinking of how Dizzy loved to say "slud" into second instead of "slid."
 Georg Jensen Wall-Mounted Clock (№. 02A4083). Price: $140. A serene, elegant face (designed by Andreas Mikkelsen, a serene Dane). Pewter (highly polished) with high-frequency quartz works. Diameter: 5", divided into sixty one-minute increments. Additional reasons to watch will be forthcoming. Imported.

U.S. Navy Aluminum Chair. First commissioned 1947 by United States Navy.
 Lightweight, fireproof, virtually indestructible. Eye-catching, oddly elegant. For seating "unexpected" dinner guests (third time this month), holding stacks of dog-eared cookbooks, reaching highest shelves (how did all that stuff get up there to begin with?), or simply sitting in while staring at your snow-covered convertible.
 U.S. Navy Aluminum Side Chair (№. 02A4128). Price: $250 ea.; set of 4, $920. Arm Chair (№. 02A4378). Price: $300 ea.; set of 2, $560. Dimensions: 16" wide x 20-1/4" deep x 33-1/2" tall. Each weighs less than ten pounds. (Shipping: pls. inq.)

Writer's block. Your mouth has remained open for the past fifteen minutes. You look hollow. You're rejecting every sentence. Welcome to Grub Street.
 Flaubert had trouble writing a line unless it was under the watchful eye of a stuffed parrot.
 After pawning his trousers, Zola got in the habit of writing while immersed in a hot tub.
 Key Top Pen (№. 02A4180). Price: $115. If this pen does nothing else, it says how much fun it is to scribble words on paper. Designed by Jean-Pierre Lepine, made in France. Lustrous aluminum body, shiny nickel-plated brass ends. To get the ink slinging, just turn the key. And just face the fact that searching for old issues of Verve may become commonplace.

Mansions creaking and shaking. Newspaper reporters camping in the parks. Rich men running through the streets in pajamas and dinner coats. Women in nightgowns sitting in the lobby of the St. Francis.
 Later, a visiting seismologist and structural engineer designs a tripod candlestick. Expressly made not to topple.
 Earthquake-Proof Candlestick (№. 02A4075). Price: $65. Steel, brass and aluminum. Industrial-chic tripod with industrial heft: large screw shaft, like a piano stool, designed to raise and lower candle base from 7" to 12." And if you need that explained further then it's probably not for you.

Arm Chair.

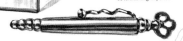

To order toll free: 800-231-7341

30

After Hours Creative
1201 E. Jefferson Suite 100B
Phoenix, AZ 85034
602 256 2648

Art Center College of Design
1700 Lida Street
Pasadena, CA 91103
626 396 2385

BAM Design
Brooklyn Academy of Music
30 Lafayette Avenue
Brooklyn, NY 11217
718 636 4124 jerbam@pipeline.com

Bielenberg Design
2004 8th Street, Suite D
Boulder, CO 80302
303 473 0757 Bielenberg@aol.com

Decker "America's Premier MicroAgency"
99 Citizens Drive
Glastonbury, CT 06033
860 659 6610

Design: M/W
149 Wooster Street
New York, NY 10012
212 982 7621 mwmwmw@aol.com

Thomas Drymon Design
3409½ M Street, N.W.
Washington, D.C. 20007
202 333 5908

Frogdesign
1327 Chesapeake Terrace
Sunnyvale, CA 94089
408 734 5800

Directory of Designers

Boxer Design
548 State Street
Brooklyn, NY 11217
718 802 9212

Cahan & Associates
818 Brannan Street
San Francisco, CA 94103
415 621 0915

Carbone Smolan Associates
22 West 19th Street
New York, NY 10011
212 807 0011

Concrete
633 South Plymouth, #208
Chicago, IL 60605
312 427 3733

Corey & Company, Inc.
63 Pleasant Street
Watertown, MA 02172
617 924 9928

Grafik Communications, Ltd.
1199 N, Fairfax Street, Suite 700
Alexandria, VA 22314
703 683 4686 jfk@grafik.com

Greteman Group
142 N. Mosely, Suite 3-A
Wichita, KS 67202
316 263 1004 greteman@gretemangroup.com

Steven Guarnaccia
31 Fairfield Street
Montclair, NJ 07042
201 746 9785

J.Graham Hanson Design
307 East 89 Street, No. 6G
New York, NY 10128
212 348 8078 jghdes@aol.com

Hornall Anderson Design Works, Inc.
1008 Western Avenue, Suite 600
Seattle, WA 98104
4206 467 5800

Landor Associates
1001 Front Street
San Francisco, CA 94111
415 955 1312

Jim Lange Design
203 S. Wabash Avenue
Chicago, IL 60601
312 606 9313

Lautman & Company
Suite 700
1730 Rhode Island Avenue NW
Washington, D.C. 20036

Michael Mabry Design
212 Sutter Street
San Francisco, CA 94108
415 982 7336

Malchow Adams & Hussey
1400 I Street, N.W., Suite 650
Washington, D.C. 20005
202 682 2500

Mires Design
2345 Kettner Boulevard
San Diego, CA 92101
619 234 6631

Moondog Studios, Inc.
210-309 W. Cordova Street
Vancouver, British Columbia
Canada V6B IE5
604 681 1944 Moondog@Cyberstore.CA

Pentagram Design
204 Fifth Avenue
New York, NY 10010
212 683 7000

ReVerb
5514 Wilshire Boulevard, 9th floor
Los Angeles, CA 90036
213 938 4370

The Riordon Design Group, Inc.
131 George Street
Oakville, Ontario
Canada L6J IE2
905 339 0750 group@riordondesign.com

Giorgio Rocco Communications
Via Domenichino 27
Milano Italy 20149

Sagmeister, Inc.
222 West 14th Street No. 15a
New York, NY 10011
212 647 1789

Sayles Graphic Design
608 Eighth Street
Des Moines, IA 50309
515 647 2922

Segura Inc.
1110 N. Milwaukee Avenue
Chicago, IL 60622
773 862 5667

Selbert Perkins Design
2067 Massachusetts Avenue
Cambridge, MA 02140
617 497 6605 jsinger@spdeast.com

The Sharper Image / In-house Agency
650 Davis Street
San Francisco, CA 94111
415 445 6199

Socio X
245 East 60th Street, 2nd floor
New York, NY 10022
212 888 2002

212 Associates
144 East 22nd Street
No. 4D
New York, NY 10010
212 925 6885

Webster Design Associates, Inc.
5060 Dodge Street
Omaha, NE 68132
402 551 0503 Twilliams@WebsterDesign.com

Index

About the Authors

Leslie Sherr writes on architecture and design for a range of international publications. A former editor at *Graphis,* her work has appeared in *U&lc, IDEA, Print, Communication Arts,* and *adobemag.com,* among others. Formerly director of communications at Desgrippes Gobé & Associates, an international strategic design and brand image firm, she travels frequently to Europe and spent two years living in Provence where she worked at the Lacoste School of the Arts. Ms. Sherr graduated with a BFA from SUNY Purchase and studied architecture criticism at Parsons School of Design. She lives in New York City.

David J. Katz founded and managed several consumer product and direct response companies (including Martec, Pierre Cardin Luggage, and the Graphyx Agency) and currently is a direct marketing and new media consultant. A contributing editor to *DM News, DRTV, NY New Media,* and *Potentials in Marketing,* he is a graduate of Tufts University and the Harvard Business School. He also appears behind and in-front-of the cameras for all three major TV shopping networks.